THE LONDON OPEN 2018

Looking back from the future, what could this catalogue tell us about the state of art and of London in 2018? It is clearly a London that is open. We can see how the city's artists explore aesthetic strategies that span the material and the virtual, the body and the site; how they reinvent identity to express subjectivity, to disinter lost histories and imagine futures. Some pursue an existential course, while others work in partnership or involve whole communities. The artists are cosmopolitan; their media are heterogeneous; their work shares no single style or ideology.

Reading the exhibitors' biographies we can see how London's art schools have played a central role, and that a wider ecology of artists' spaces, public institutions and commercial galleries combined with a complex economy of public and private support made the London of 2018 a dynamic crucible of culture.

The number of submissions alone attests to the capital's creative health. Weighing in with over 2,600 submissions, this edition of *The London Open* attracted the highest number of applications since it was founded in 1932. The rich panoply offers a remarkable snapshot of the city's extraordinary vibrancy: every single artist who made a submission had the opportunity to show their work on a digital display within the gallery. Yet the selection panel chose twenty-two artists to offer the public a full immersion in a sequence of singular oeuvres.

The panel is composed of a number of people with important roles in the 2018 London art world. One of the UK's most celebrated artists, Ryan Gander, is part of the team. Records will reveal that in the spring of 2018 he transformed the Lisson Gallery into a giant hour glass. Deputy Editor of the influential art magazine Frieze and a curator of East London's Open Source Festival, the writer Amy Sherlock brought a seasoned critic's eye to the selection process, while pioneering gallerist and champion of emerging artists Paul Hedge, co-founder of

THE 2 LONDON OPEN 1 8

Whitechapel Gallery

Iwona Blazwick, OBE
Director, Whitechapel Gallery

the East End's Hales Gallery, was on the alert for unrecognised talent. They were joined by Robert Suss, co-founder of the Franks-Suss Collection, who supports and collects the work of British artists alongside contemporary art from Asia and Latin America. Working with her colleague Cameron Foote, Whitechapel Gallery Curator Emily Butler led the process, including shortlisting, making studio visits, installing and offering a journey through the themes and interests of the artists' diverse practices.

The 2018 edition of *The London Open* testifies to a remarkable epoch in terms of both practice and philanthropy. It has been the patronage of Ravi Chidambaram and Evgeny Tugolukov in combination with Arts Council England and the generosity of those artists who conceived and donated editions that has made the exhibition and its expansive programme of performances, readings, workshops and forays into the public realm possible.

A cautionary note: if in the year that followed the publication of this catalogue the UK did indeed pursue its perilous course towards isolationism by leaving the European Union, then we may have to regard this London of 2018 as we regarded 1915 St Petersburg, home of Suprematism, or the early 1900s Paris of Cubism and Surrealism, or modernist Rio of the late 1950s, or the Minimalist, performative New York of the 1970s – as defining a moment in art, yet vulnerable to decline.

Like all the metropolitan centres that have nurtured the great avant-gardes, London's golden age may also wain. Its ecosystem is both protean and fragile. Perhaps the cultural historians of the future will look back at the surging property prices as akin to the tulip mania of

seventeenth-century Holland. Artists are being driven out of the city to find cheaper accommodation and affordable studios. Escalating rents are also forcing smaller galleries to close, making financial survival for emerging artists a daily struggle. The acronym S.T.E.M. (science, technology, engineering, maths) shaping the school curriculum does not include an 'A' for the arts. Higher education is being instrumentalised in the name of 'employability'. Yet how can any business, culture or society flourish without left-field ideas and experimentation that has no capitalist purpose?

The Whitechapel Gallery will remain fiercely committed to embracing the cosmopolitanism of the London art world, in part by seeking to understand the factors that inspired so many outside the metropolis to vote against remaining in the European Union. Perhaps the exodus from the city will invigorate the suburban, post-industrial and rural communities that have expressed their frustration through the Leave vote. Perhaps we can reverse the anti-urban, nationalist turn, so that the vivacity of the London art scene lives on and prospers in tandem with a multiplicity of creative hubs around the UK.

SELECTION PANEL STATEMENT

After a month of reviewing applications online, *The London Open* selection panel spent two productive and enjoyable days together in a room simply looking and discussing. While we were apprehensive about the responsibility of choosing artists and works, we were driven by an interest in learning more about what was going on among artists in London right now and bringing our own thoughts to bear on the works presented in order to produce a cohesive show.

On behalf of the selection panel, I wish to extend thanks to all of the artists who took the time to apply. It is important for the life of this city that artists continue to work and live here and that their work is reflected back to the population. It is also important that the status quo is continually challenged.

All six selectors have experienced the creative life that London has to offer at different times and from unique perspectives. We hope that this is visible in our selection.

My own experience of London began back in 1980, arriving in South East London as a student on the Goldsmiths College Fine Art course. At that time, it was common for aspiring artists from poorer backgrounds to be offered government grants and have fees paid to attend art school. Despite the lack of money and status afforded to artists back then, they could occupy endless broken down buildings as studios and aspire to make works of art unrestricted by storage, exhibition or market pressures.

Much (Thames) water has gone under the bridge since then, which was certainly reflected in the work submitted to *The London Open* in 2018. Artists are generally working on a smaller scale and with an awareness of the international market. Time-based media and film work

Paul Hedge,
Hales Gallery

formed a very large part of the entries, alongside works made with found materials and temporary installations. These factors are now normal for artists working in an expensive multicultural city, cramped for space and with a volatile commercial gallery scene.

However, it was reassuring to see how creative and resourceful current London-based artists could be with such restrictions. It was also good to see that London's demographic is manifest in a broad range of works made by artists from ethnically diverse backgrounds and politically engaged contexts. The works reflected on socio-political issues from the past three years: Brexit, Trump, equality of gender, queer identities, gentrification etc.

I hope that the gallery-going public enjoy our selection as much as we have been challenged by what we have seen. I certainly found the experience rewarding. It was fascinating to see how London artists manage to be both local and global in their vision.

Paul Hedge, on behalf of *The London Open 2018* selection panel: *Emily Butler*, Mahera and Mohammad Abu Ghazaleh Curator, Whitechapel Gallery; *Cameron Foote*, Assistant Curator, Whitechapel Gallery; *Ryan Gander*, Artist; *Amy Sherlock*, Frieze Magazine and *Robert Suss*, Collector.

A TOUR
OF THE OPEN

London and the UK have gone through a great deal of change during 2015—18, since the last edition of *The London Open*. What does it mean, in the face of terrorism and tragedies, and despite the rise of right-wing politics and insularism, to remain culturally 'open'? This was also one of the questions raised by the Mayor of London's #LondonIsOpen campaign, which came in the wake of Brexit.

We aspired with the selection panel for the exhibition to offer a positive message about the vitality and diversity of artistic talent in London but for it also to reflect on the word 'open'. We wanted the exhibition to demonstrate London's current and continued role on the international cultural scene, as a destination for learning and practice. Focusing on the city's diversity was an important part of this message and, very early on, all the invited panellists expressed how important this would be for the 2018 edition. A selection panel's purpose is also to bring a range of opinions, discourses and debates to the table from different sectors of the art world.

The London Open has no stated theme for submissions, a wide brief that presents both an opportunity and a challenge for all involved. However, since the submitted artworks must date from after the last edition in 2015, the show focuses on the present moment. One key issue, which clearly emerged from looking at such a diverse pool of work from 2,600 submissions, was the question of representation. How to choose artists that stand for what is happening now and have the authority and sensitivity to speak on behalf of others?

With recent debates about political, religious, gender and racial representation — from alt-right politics, fundamentalism, #metoo to 'black death spectacle' – we were drawn to artists whose work genuinely engages with the subjects explored in it, through grassroots collaboration or sustained engagement, rather

Emily Butler
and *Cameron Foote,*
Whitechapel Gallery Curators

than on their temporary newsworthiness. The artists for whom we opted take a holistic and considered approach to their subject matter, being neither exploitative, sensationalist nor condescending.

Common interests that emerge from the selection can be summarised into three broad overlapping areas: our relationship with nature, the material world and the rapidly changing urban environment; our reliance on technology and systems of control – including copyright and ventures into space; human relations, gender, race and queer representation, activism and the legacy of exploitation and postcolonial histories. All of these concerns are conditioned by the experience of living in this global city in the present moment.

We chose work across all media, including painting, sculpture, installation, performance and video, to be shown in the gallery and online. The visual, sound and narrative strategies deployed in these works push aesthetic limits, test the borders between fact and fiction, and question the institutions of art. The exhibition offers a journey of connections and alliances between the broad range of subjects, strategies and media employed.

The final selection presents just one snapshot, and countless arrays of equally fascinating exhibitions could have been made from all the submissions. Some of the work of the artists who applied can be seen on a digital display in the gallery. The variety and criticality of the artistic practices represented both in the show and the digital display are testament to artists' ability not just to survive in this city but to thrive in it.

How to choose artists that stand for what is happening now and have the authority and sensitivity to speak on behalf of others?

9

The exhibition begins in a tongue in cheek manner in GALLERY 1 with a work by ALEXIS TEPLIN that tests the limits of the art institution itself — a large-scale metal stretcher featuring deconstructed segments of canvas in bright blocks of colour. Part painting, part sculpture, it creates an environment in front of which three performers offer an absurdist narrative on different occasions during the run of the show. The dense yet fragmented nature of the work and its accompanying script contribute to questioning the formal experimentations of artistic avant-gardes, as well as the all-encompassing art-historical narratives of the institutional framework.

A playful blurring of boundaries of genre and media is also apparent in JONATHAN TRAYTE's ceramic and bronze sculptures-cum-lights, elevated on brightly coloured carpeted plinths. While Trayte conceives of his sculptures as families, whose relationship and vocabulary of form he invites the public to decipher, a call to untangle a set of relations is explored by GABRIELLA BOYD in her groups of paintings. In works referring to bodily connections, feelings and emotions, each image appears disrupted either formally or in terms of an arrested narrative. Unravelling the most basic universal experience, FRENCH & MOTTORSHEAD confront us with our own mortality. *Grey Granular Fist* (2017) and *Homebody* (2018) are audio pieces that describe in meticulous and forensic detail the processes of dying and decomposition. The first envisages this happening in a gallery or museum space, the second at home in bed. Both works offer a strangely meditative experience, placing the viewer at the centre of the narrative and tackling a subject that is rarely discussed in such a factual or experiential manner. Death is also investigated by DES LAWRENCE, who traces public figures' legacies through visual obituaries. Rather than being straightforward representations, they bring history painting into the digital era by focusing on visual associations now possible through image search engines.

CÉLINE MANZ looks at the close collaboration of seminal artist couple Robert and Sonia Delaunay, questioning the boundaries of their practice, and also testing the limits of copyright through her own appropriation of an *Endless Rhythm* motif. Similarly, GEORGE EKSTS probes the idea of the completion of an artwork, always deferring the resolution of the placement of objects in physical and digital realms, time and space.

In his video work, TOM VARLEY invites us on an intimate journey through the existential musings of a satellite, and considers how governments and corporations influence our relationship with technology. The biases of technology are also addressed by RACHEL ARA in her monumental self-built neon sculpture that displays its own constantly shifting value based on an algorithm drawn from purposefully selected criteria such as age, gender, sexuality and race.

RENEE SO explores stylistic purity of technique and form in her textile and ceramic works, inviting us to make cross-cultural connections; her vessels and reliefs point equally to ancient Mesopotamia and to modernist masters, always working with the possibilities of the medium. RACHEL PIMM also investigates the potential, and the limitations, of high-end architectural ceramic tiles, charting the process of their manufacture from the initial extraction of minerals used in their fabrication to their fine finishing or rejection from the production line.

At the heart of the main space is a pile of rubble where invasive plants valiantly attempt to reclaim territory. RACHAEL CHAMPION's urban landscape sourced from demolition rubble draws attention to the rapidly changing city fabric but also to the origins of construction materials, investigating the contested nature of spaces where political, commercial and ecological concerns intersect.

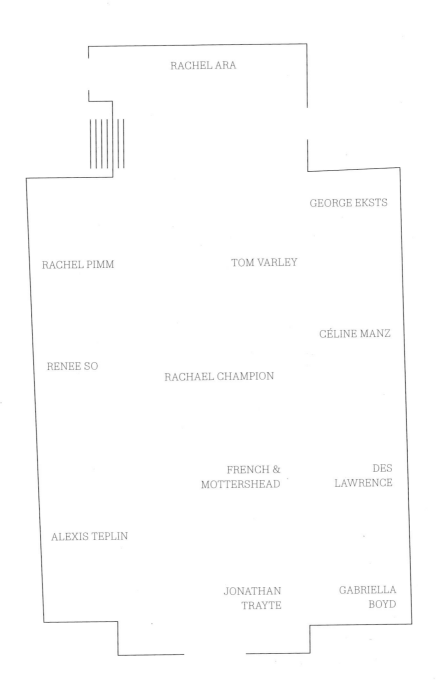

RACHEL ARA

GEORGE EKSTS

RACHEL PIMM

TOM VARLEY

CÉLINE MANZ

RENEE SO

RACHAEL CHAMPION

FRENCH &
MOTTERSHEAD

DES
LAWRENCE

ALEXIS TEPLIN

JONATHAN
TRAYTE

GABRIELLA
BOYD

ANDREA LUKA ZIMMERMAN

GALLERY 9

URIEL
ORLOW

LARRY
ACHIAMPONG

RICHARD
HEALY

ELISABETH
TOMLINSON

AYAN
FARAH

GARY
COLCLOUGH

VIKESH
GOVIND

HANNAH
BROWN

TOM
LOCK

GALLERY 9 is handed over to the collaborative practice of ANDREA LUKA ZIMMERMAN, an artist and activist. A film and poster installation traces activism in Newcastle and resistance movements elsewhere in the UK. Through a series of associated events, including those highlighting the human rights of asylum seekers and celebrating seminal texts from May '68, Andrea honours a number of campaigns for social equality and change.

How can plant life be implicated in human structures of oppression? GALLERY 8 opens with URIEL ORLOW's *The Fairest Heritage*, (2016) a slide projection revisiting a documentary commissioned in 1963 by the South African Botanical Gardens in Cape Town. Collaborating with performer Lindiwe Matshikiza, he invites us to confront this archival material from the apartheid era. This work is part of a wider project called *Theatrum Botanicum* (2015—18) that examines the co-option of the botanical world by political actors.

LARRY ACHIAMPONG looks at colonialism from a different perspective, imagining a possible future after its demise. A young RELIC TRAVELLER traverses a landscape, coming across forgotten ruins of a fallen empire and testimonies of past traumas. AYAN FARAH uses the sap, dried leaves and roots of plants to make natural dyes for historic linens that refer to the nineteenth-century slave trade. *Zizi Oasis* (2018) features elegant water-carrying vessels made from clay sourced from a contested border region of postcolonial Algeria and Morocco.

RICHARD HEALY's *Lubricants and Literature* (2016) offers a computer-generated guided tour of an imaginary building full of extravagant surfaces, esoteric symbols and queer erotic fantasies. Alongside the video is a series of slender functional sculptures that act as lamps and book rests. Nearby, ELISABETH TOMLINSON's series of three videos studies the female gaze and desire through an edited series of candid and sometimes contradictory conversations with a nude male subject, recorded in the private space of her own bedroom.

VIKESH GOVIND's video *Shoes* (2017) opens with two figures standing on the bank of a lake in Wanstead Flats, East London. The short film is accompanied by a poem by spoken-word artist Sugar J (Jeremiah Brown) that reflects on racial identity and takes us on a journey from the park to the streets and private spaces around the city.

The works of HANNAH BROWN and GARY COLCLOUGH consider the constructed nature of the landscape, and engage with the history of representing it. Brown creates paintings of contested rural sites or picturesque idylls cast in an uncanny twilight. Colclough, on the other hand, paints finely detailed scenes from images that he combines using digital software. His canvases are set within wooden structures that expand and re-define the idea of a picture frame as a sculptural element.

The final space in the exhibition contains a video and sound installation by TOM LOCK titled *Within* (2017). Extending across four screens, psychedelic forms and symbols surround and immerse visitors in an extra-terrestrial encounter. The narrated soundtrack draws on science fiction writer Octavia E. Butler's 1987 novel *Lilith's Brood*, in which aliens pose an ethical question: in the face of the human race's impending self-destruction, is hybridity our only means for survival?

22
ARTISTS
LIVING
IN

E.B. *Emily Butler* C.F. *Cameron Foote* J.S. *Jane Scarth*

AND
WORKING

LONDON

Larry Achiampong

Design for *PAN AFRICAN FLAG FOR THE RELIC TRAVELLERS'*
ALLIANCE (MOTION), 2018, printed banner, 392.5 × 110 cm

Larry Achiampong works across video, sculpture, performance, music and text to reflect on the impact of colonial histories, exploring notions around race, class and culture in the digital age.

'Every place has its struggles... Our lives are political because our bodies are'

This is the reflection of the central voice in Achiampong's *Relic 1* (2017), which is set in a desolate landscape somewhere in the UK. The film follows a young Relic Traveller who is attempting to uncover evidence of the traumas of colonialism, on physical and metaphorical levels and who finds this vocal testimony from the past. The camera cuts between shots of the empty, peaceful terrains and locations of uncertain significance — sites for mysterious rituals — underlining the intersection of fiction and testimony, narrative and history, explored in the work. The voiceover leads the listener cathartically through trauma and claustrophobia to release, via the poetic and the sublime.

PAN AFRICAN FLAG FOR THE RELIC TRAVELLERS' ALLIANCE (MOTION) (2018) is an extension of Achiampong's Relic Traveller project, which imagines a future of Pan-African prosperity. The appliqué flag features 54 stars representing the nations of Africa. The colours are symbolic: green reflecting its land and resources, black representing its people, red referring to their past struggles and gold symbolising prosperity to come. All these elements are brought together in a form suggesting a human figure in flight, an Afrofuturist icon moving towards unity and equilibrium and a symbol for the Relic Traveller.

Achiampong's work brings together digital and analogue techniques, reflecting on technology's democratic possibilities. He works both collaboratively and under the guise of alter egos: Blackph03nix, Cloudface and Harry H'atchiampong from Biters (a project with David Blandy), exploring the subject of cross-cultural identity.
E.B.

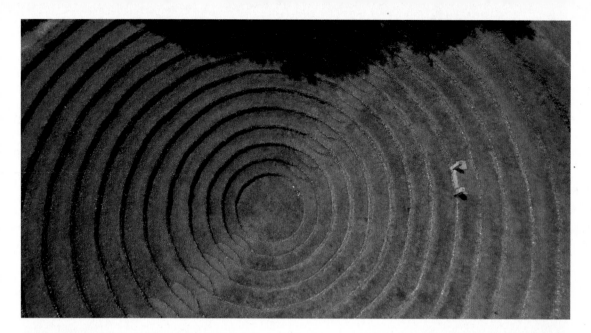

Stills from *Relic 1*, 2017
single channel 4k video with stereo sound, 14:12 mins

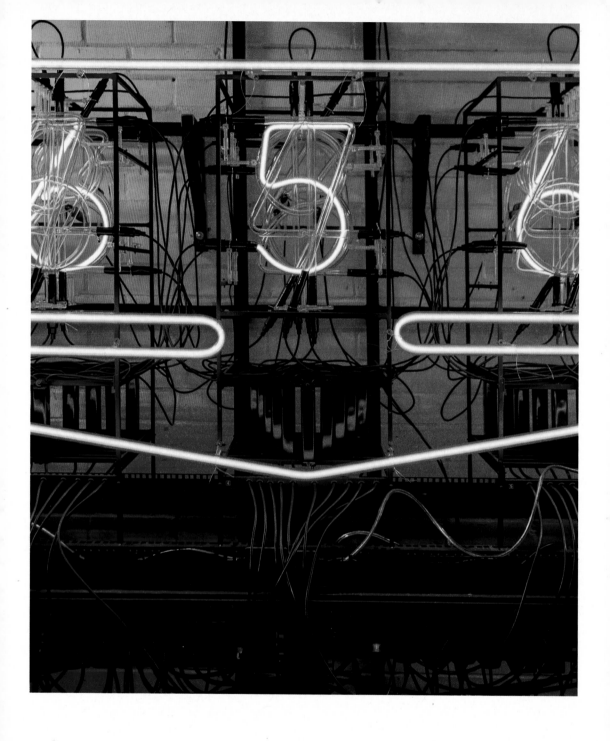

This page and following spread:
This Much I'm Worth (The self-evaluating artwork), 2017
83 pieces of neon, recycled server room equipment, electronics,
computers, IP cameras, programming, 420 × 160 × 90 cm

Rachel Ara

Rachel Ara is a conceptual and data artist who explores the relationships between gender, technology and systems of power.

This Much I'm Worth (The self-evaluating artwork) (2017) states its function clearly and with humour: it is an artwork that presents its own fluctuating value. The work was engineered and programmed by Ara, and she has collaborated with a female glassblower, Julia Bickerstaff, to manufacture its sets of seven large red neon numerals. Created on a monumental scale at over four metres in width, it is a comment on the excessive importance placed on market value and questions the parameters that are established to calculate this.

Ara has programmed the work taking into account several deliberate factors including: age, gender, sexuality, race using data mining algorithms called 'the endorsers' and by calculating social media presence - if you tweet about the work it reacts instantly. It also assesses the numbers of gallery visitors looking at the piece through the use of web cameras.

The aesthetics of the neons refer to Nixie tubes or cold-cathode tubes used in early calculators and numerical displays, but also the bright lights of sex-shop signs. All the physical components of the work are clearly visible: from the 83 neons, their metal cages ('the keepers'), multiple cables, IP cameras, elements of server-room computer equipment that host the electronics, to the brackets that hold the weight of the piece.

Ara has a background in programming and cabinet making. She brings these skills to explore the possibilities of technology, making complex works that interrogate their own function and question technological binaries. In 2016 she was awarded the Aesthetica Art Prize for a prototype of the piece.

E.B.

'This Much I'm Worth (The self-evaluating artwork) *is part of a wider body of work that addresses feminist issues, conspiracies of silence and misinformation. (It) has been made all the more complex by my own ambition to work with only women experts in fields dominated by men.*'[1]

[1] Rachel Ara, 'The Making of a Digital Masterpiece', 2017: www.2ra.co/tmiwfull.html

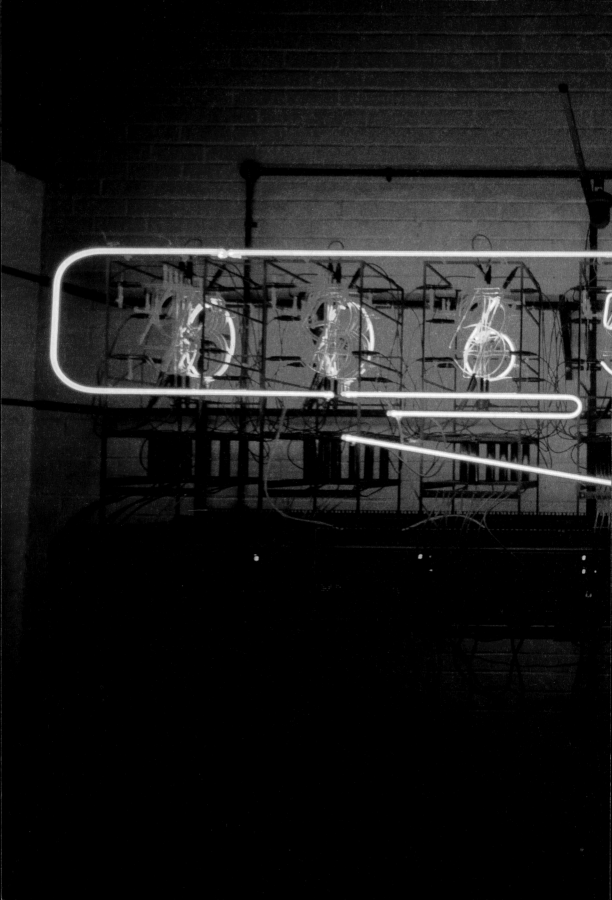

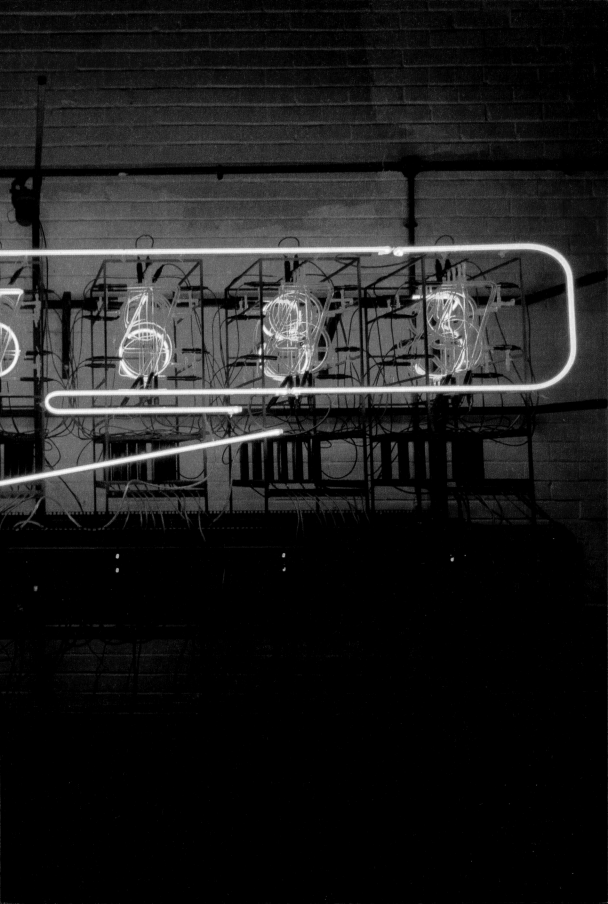

Gabriella Boyd

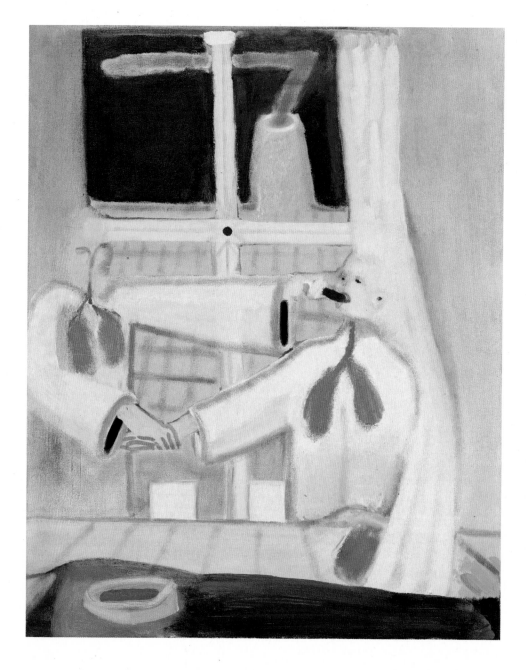

The Optimist, 2018
oil paint on canvas, 50 × 40 cm

Draft, 2018
oil paint on canvas, 145 × 89 cm

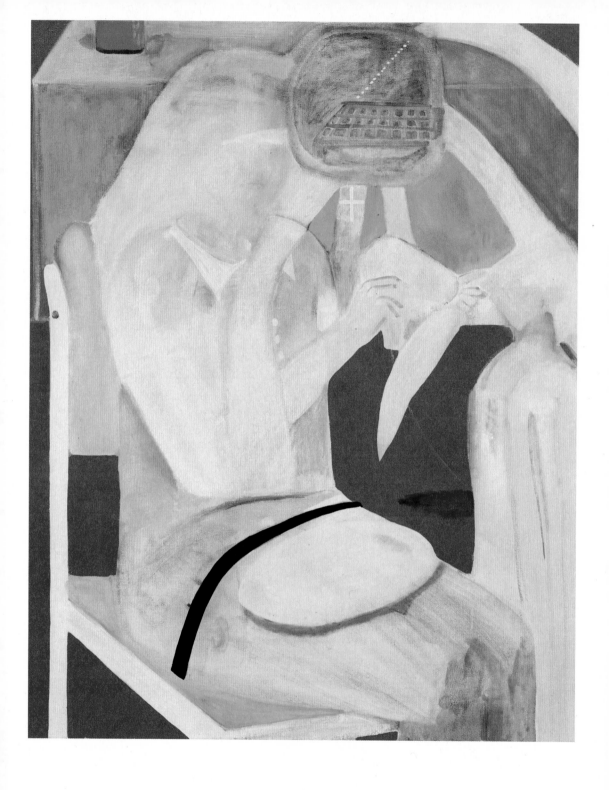

Tomorrow Started, 2018
oil paint on linen, 126 × 101 cm

It is difficult to put into words the experience of looking at Gabriella Boyd's paintings and fittingly, non-verbal communication is often the subject matter of her work:

'Celebrating futile attempts at communication in human relations, I invite the viewer to navigate through tones of desire, care and medicinal support, forms and figures lodged and dissolving into their surroundings.' [2]

In *The Optimist* (2018), a stylised doctor in a priest-like cowl takes the temperature of a patient. One hand directly touches skin, while the other bears a thermometer, which seems to pour its red liquid into the lungs of both figures. Red lines pervade the picture, tracing the outlines of the two bodies, a window frame and a chequered landscape with crane-like shape beyond.

Tomorrow Started (2018) features what might be a mother drying her daughter's hair, in a tender and banal moment of intimacy. An ambiguous architectural roundel at the top of the painting connects the two women and the background with tendril-like beams.

While these two paintings show pairings of figures, her others are often more abstract in appearance. *Draft*, for example, features a blue cloud-like shape suggestive of the provisional. Boyd invites us to draw connections between the forms, symbols and brush marks in her abstract paintings and the figurative works:

'A seemingly abstract painting, when paired with a more straightforwardly narrative scene can take on figurative qualities and similarly the figurative painting can be broken down into abstract relationships between shapes and colour.' [3]

C.F.

[2] Gabriella Boyd, *Thoughts on My Paintings*, 2018
[3] Ibid.

The field next to Tesco that is soon to be built on, 1, 2016–17
oil paint on marine plywood and oak, 36 × 46 cm

Hannah Brown

Victoria Park 12, 2016
oil paint on marine plywood and oak, 32 × 40 cm

Hannah Brown's artistic practice is rooted in ideas about the rural: the tension between town and country, environmental destruction and the beauty of the English landscape in the popular imagination:

'I feel that painting is a conversation. I hope to open a dialogue about nature and the way we use it, commodify it, own it, and project emotions or identity onto it.' [4]

On display are paintings of different scales and techniques. *Victoria Park 12* (2016) and *The field next to Tesco that is soon to be built on, 1* (2016–17) are painted on small (40 cm) marine plywood and oak boards. Executed in multiple layers of oil paint finished with a high-gloss varnish, they have a vivid depth. All of Brown's paintings are derived from detailed photographic studies taken while visiting her chosen locations, but here she excludes roads, electricity lines and people from the scenes, signs of human and industrial activity that might situate them in a particular time or place. Instead, the landscapes have a timeless and idyllic quality. Only the title of the works locates them or alludes to the constructed or contested nature of the urban green spaces depicted.

At a larger scale of around two metres in width are *Hedge 3* (2017) and *Washford Pyne 11* (2016). For these works, Brown translated a technique of 'day for night' from the field of photography and cinema into the medium of paint. While her source images were originally taken in the daytime, she shifted the colours and tones to dusky blues and purples, creating an unsettling twilight effect.

C.F.

4 Hannah Brown, *'Guest Artist: Interview'*, *FLOORR*, 30 September 2016: www.floorrmagazine.com/issue-6/hannah-brown

Hedge 3, 2017
oil paint on linen, 121 × 171 cm

Rachael Champion

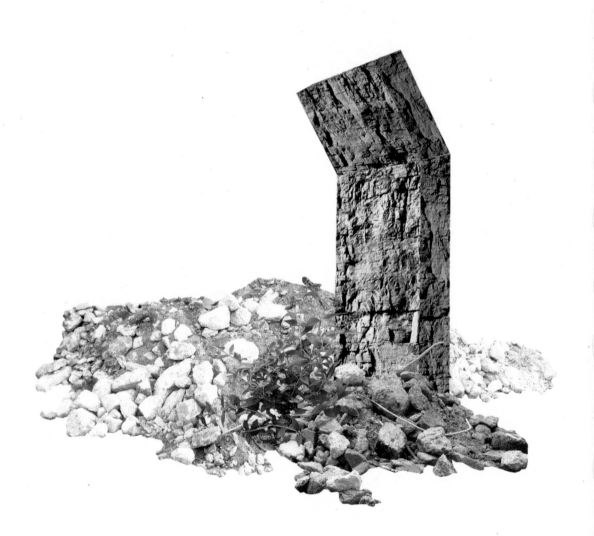

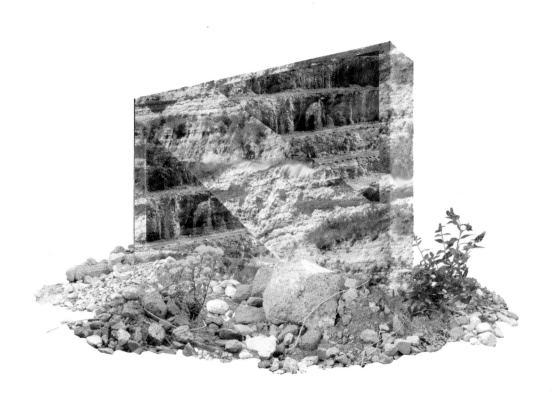

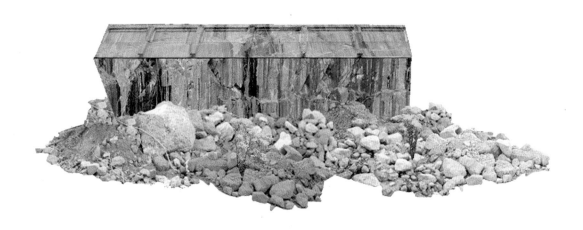

Studies for *Blackwall Reach*, 2018
digital collage, dimensions variable

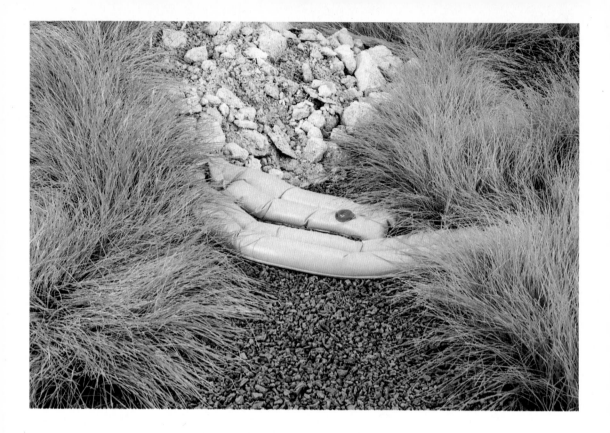

All around London are spaces in transition, from vast demolition sites overrun with machinery to vacant plots taken over by wild plants while speculators wait for the right economic conditions for development. Rachael Champion creates site-specific installations that investigate these contested urban spaces, where political, commercial and ecological concerns intersect.

For *The London Open 2018*, Champion continues a body of work that began in a railway arch in Nine Elms, Vauxhall, as part of the 2016 Chelsea Fringe Festival. For this project, she gathered 15 tons of demolition rubble from the site of the nearby BT Telephone Exchange, which was undergoing development for housing. She created an indoor landscape using the rubble, integrating a variety of landscaping materials, bulging water-filled plastic bags, rubber bark chippings and living plants.

For the Whitechapel Gallery, Champion has created sculptures that reproduce architectural details from Robin Hood Gardens, a renowned modernist residential housing estate in Poplar, East London, designed in the late 1960s by architects Alison and Peter Smithson, which is currently being demolished for redevelopment. The Smithsons are also known for their contribution to the seminal 1956 exhibition at the Whitechapel Gallery, *This is Tomorrow*, for which they created, together with Nigel Henderson and Eduardo Paolozzi, a surrealist *Patio and Pavilion*, replete with sculptures inspired by the bomb sites and construction projects of post-war London. In the same downstairs gallery where *Patio and Pavilion* was realised, Champion places her sculptures inspired by architectural features from Robin Hood Gardens. The sculptures are clad in images of limestone quarries in the Peak District.

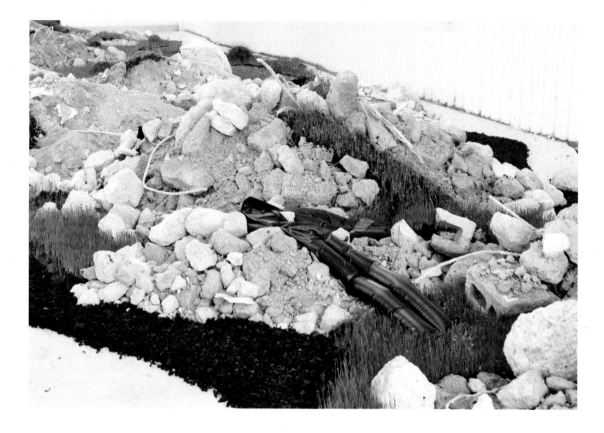

'*The calcareous landscapes* [of these quarries] *refer to the material origins of our build environment. Lime is a key ingredient in our most ubiquitous building material: cement.*' [5]

The sculptures are placed amidst demolition debris accumulated from sites around London. The scene is also punctuated with plants, in this case, a non-native invasive species that will spread across the installation throughout the duration of the exhibition.

C.F.

[5] Artist's Statement, June 2018

New Spring Gardens (details), 2016
building site rubble (BT telephone exchange, Vauxhall), wheat grass,
rubber bark chippings, pool cover weights (water bags), 150 × 900 × 2800 cm

Outside in the New Light, 2017
oil paint, birch plywood panel, linen, teak, 85.5 × 95.5 × 1.8 cm

New Seeker (detail), 2017
oil paint, birch plywood panel, teak, 160.5 × 120 × 120 cm

Gary
Colclough

Gary Colclough makes vivid, small-scale landscapes integrated into wooden frames that transform them from flat paintings into sculpture. Instead of being square or rectangular, the frames are made up of triangles, diamonds and beams that suggest signposts, flags or ritual devices.

A regular rail commute into London is a source of inspiration for the landscapes:

'My journey takes me through Woking, where H.G. Wells lived and wrote The War of the Worlds.[6] *The town and surrounding area feature heavily in the first part of the book and as the train carries me further into the Surrey countryside I try to imagine it as a backdrop for an invasion and other doomsday scenarios.'* [7]

[6] H.G. Wells,
 The War of the Worlds, 1897
[7] Artist's Statement,
 March 2018

Colclough searches the internet for photographs of the scenery that the train traverses. He digitally alters his selected images, combining two or three scenes into one. In *Outside in the New Light* (2017), for example, he splices a marsh replete with tall reeds together with a distant field and horizon line to create a fictional view. The photomontages then form the basis for detailed monochrome oil paintings that can sometimes take Colclough more than 100 hours to complete. Finally, glazes of single colours or gradients are added, creating a duotone effect that has associations with pottery decoration or toile fabric making. Cumulatively, the layering of location and technique generates an uncanny and futuristic mood.

The forms in Colclough's paintings interact closely with the framing structures that he deploys. The curved path that appears in *Once Taken* (2017), for example, is echoed in the sharp angle of the surrounding wooden support. In *New Seeker* (2017), a double-sided triangular painted panel is placed at the head of a structure suggestive of ritualistic function.

The mystery and complexity of nature is explored further in *Three Peaks* (2017). While digging in his back garden, Colclough unearthed rocks, coal and fragments of bone, objects whose formless quality fascinated him. By isolating each ambiguous shape against a single pastel-tone background, Colclough highlights their strangeness.

C.F.

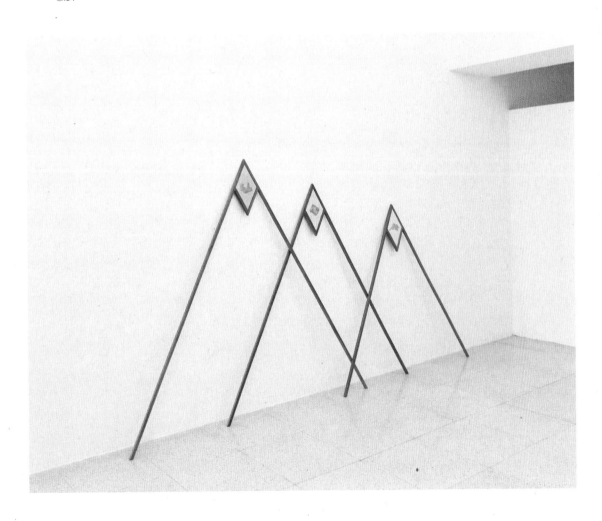

Three Peaks, 2017, oil paint, birch plywood panel, teak
140 × 165 × 1.5 cm; 126 × 140 × 1.5 cm; 112 × 131 ×1.5 cm

George Eksts

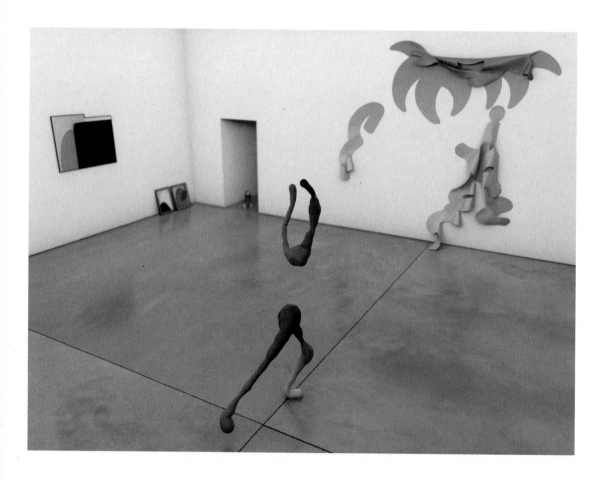

Still from *Rehearsal*, 2017
HD video with sound, 04:00 mins

George Eksts questions notions of completion, permanence and originality in animation, photography and collage.

Rehearsal (2018) offers the promise of a work to come, yet conclusion never occurs. The installation presented in the gallery space includes a digital animation, a vitrine with collage parts used in the animation and a wall-based vinyl cut-out; these are, however, just temporary placements of elements in space and time.

The animation takes place in an immaculate white cube space with brushed concrete floors — the ubiquitous space of the art world. A schematic figure twirls within it, and as the camera follows the dancer we encounter artworks hung on walls or propped on the gallery floor. The figure's form and colour scheme are echoed in the artworks. Eksts offers a double *mise en abyme*: not only do we see artworks within an artwork, but as we step back from the animation, we realise one of the virtual artworks also features in real life on the gallery wall. Which came first: the sculpture or the animation?

Through a game of virtual and physical mirrors, Eksts destabilises notions of originality and linear time. He creates his own visual language, interchanging physical and digital components in an endless set of correlations with multiple associations.

E.B.

'I've always been fascinated by placeholders, variables, lacunae, support structures, anything that is not an end in itself but suggests interchangeable and unknown possibilities.' [8]

[8] 'George Eksts in conversation with Sarah Grant,' *Victoria and Albert Museum Blog*, 2012: www.vam.ac.uk/blog/engraved-ornament-project/ornament-prints-and-contemporary-art

Wild Service, 2018
cut vinyl, dimensions variable

Bonfire, 2017
paint on panel, brass, 40.5 × 39.5 cm

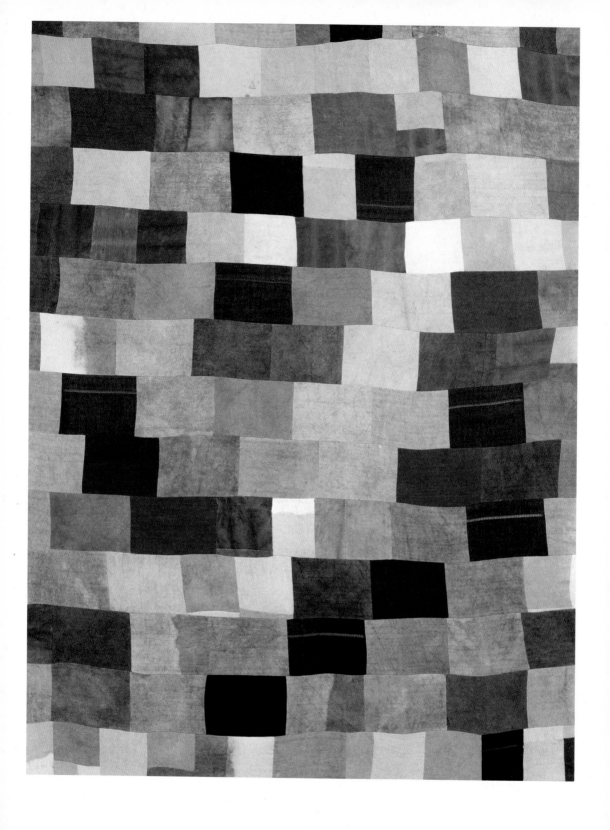

Waris–Indigo, 2018, clay, Dead Sea mud,
indigo, India ink and carob on linen, 200 × 150 cm

Ayan Farah

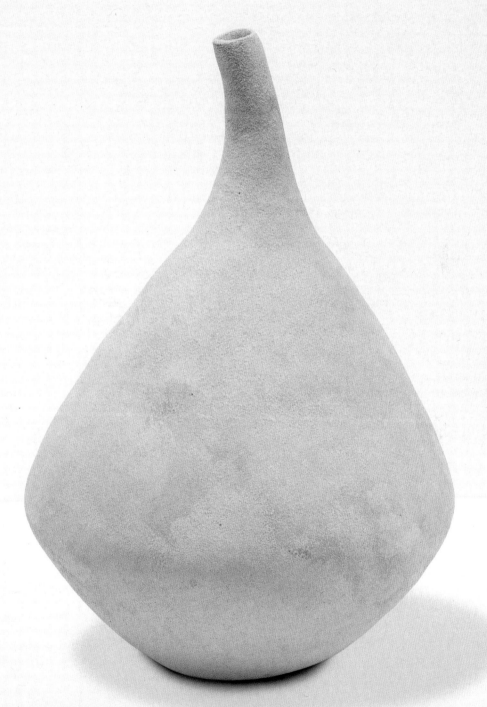

Zizi Oasis (detail), 2018, clay, cloud seeded rain water, linen
dimensions variable, linen, 190 × 60 cm

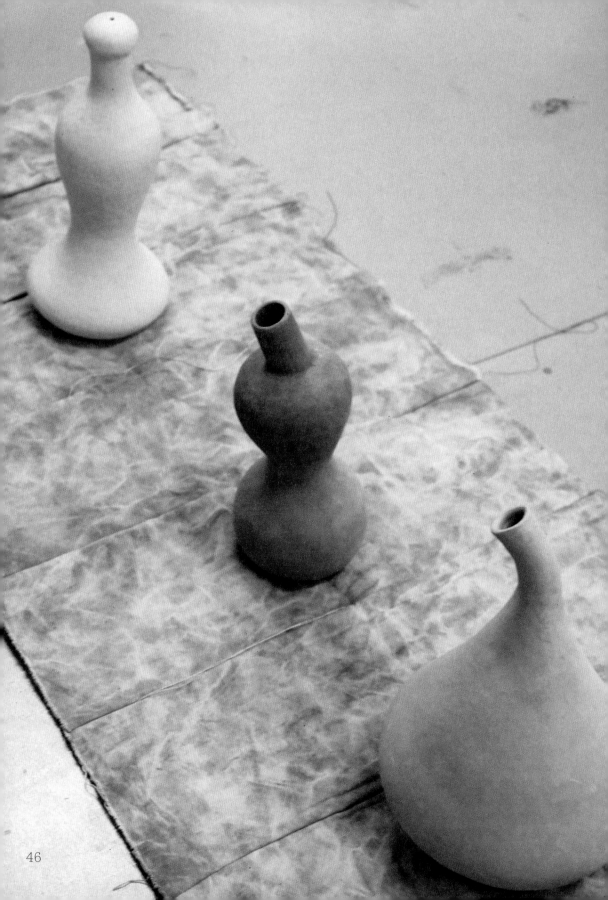

Ayan Farah's subtle and complex art includes large abstract paintings that trace squares, grids or maps, and earthy ceramic vessels that echo the forms of ancient pottery. On display are three works, each made with different processes and material associations.

Farah often uses historic fabrics in her works. For *RA—Hammar* (2018) she selected domestic linen from Belgium, most likely dating from the 1880s. In the mid-to-late nineteenth century, slaves still picked much of the cotton that was woven in mills across Britain and then traded for Belgian linen. Farah has dyed the linen using indigo from plants grown on her allotment in East Ham exposing the central part of the work to the sun, to create a dynamic streak of light blue. This method of bleaching is similar to the process of making a photogram, a type of camera-less photography that also originated in the nineteenth century. The 'RA' in the title refers to the Egyptian sun god Ra, while the word 'Hammar' indicates the island of Hammarö in Sweden, the place where Farah exposed the work to the sun.

Waris—Indigo (2018) is from a series of patchwork textiles that stitch together remnants from Farah's past works and are titled after the names of Somali women in her family. While they resonate with modernist abstract painting by the likes of Agnes Martin, they equally bring to mind maps or quilts:

'All the patches are offcuts from previous works. There's a tradition amongst Somali women to give cloth as a gift, often so you can use it to make your own garments.' [9]

Zizi Oasis (2018) comprises a cluster of earthenware and stoneware vessels, also resting on a sewn textile fragment. The pots are modelled after calabash fruits or gourds, natural forms that are used to carry water. The title refers to the Ziz Valley in southern Morocco and Algeria, an oasis in the Sahara rich in mineral resources. This territory has long been disputed following the misidentification of the region by colonial powers when drawing up the borders of the French protectorate in Morocco.

C.F.

Zizi Oasis (detail), 2018, clay, cloud seeded rain water, linen, dimensions variable, linen: 190 × 60 cm

[9] Artist's Statement, April 2018

French &
Mottershead

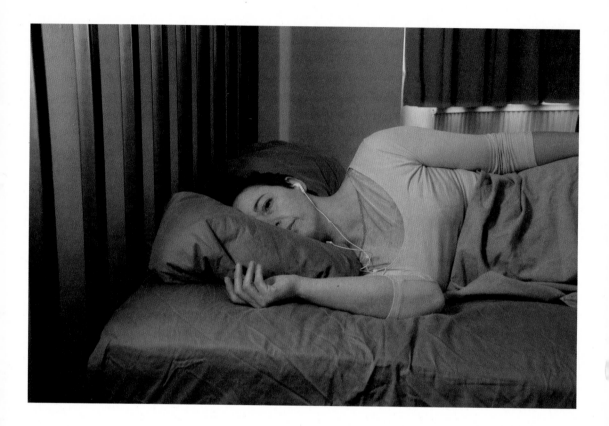

Homebody, 2018
audio, online broadcast, approx. 23:00 mins

The artist duo French & Mottershead (Rebecca French and Andrew Mottershead) create photography, video, sound, installation and online interventions that estrange and reframe our relationships with familiar locations.

For *The London Open 2018* they present two closely related artworks. *Grey Granular Fist* (2017) is a sound piece to be experienced from bent plywood chairs of the type commonly found in public buildings. In the style of a museum audio guide or perhaps a self-help podcast, a soothing but authoritative voiceover addresses you directly, describing what happens to you from the moment of your very last breath. In the hours, days, weeks and years following your death, your body slowly rots and fuses with the wooden chair on which you are sitting. Under controlled lighting, beneath an air-conditioning unit, and carefully monitored by the gallery staff and conservators, you become just like the artworks that surround you. The phrase 'grey granular fist' refers to your shrivelled and decomposed brain, a description found in one of the many forensic case studies that the artists consulted when writing the script.

'We've been looking at the story of human decomposition through the eyes of forensic anthropologists. What we've found out is that the story of human decomposition is about transformation, renewal and change.' [10]

From the same series, appropriately titled *Afterlife, Homebody* (2018) is a new work that is intended to be listened to at home through headphones while lying in bed. Both artworks confront us with a universal issue that is seldom discussed in such factual terms—dying—offering a strangely meditative experience in the process.

C.F.

[10] Andrew Mottershead in Catherine Chapman, 'British Artists Recreate the Experience of Being a Decaying Corpse', *The Creator's Project*, September 2016: creators.vice.com/en_uk/article/kbnvm3/artists-recreate-experience-body-after-death

Grey Granular Fist, 2017, chair, sensor,
audio player, headphones, audio (set of 3), 24:00 mins

Voices and footsteps
echo and decay
from room to room
Cool dry filtered air
circulates constantly
around your body

This page and following spread: stills from *Shoes*, 2017
digital film, 03:40 mins

Vikesh Govind

Working with a close team of collaborators, including actors, poets, musicians and sound designers, Vikesh Govind makes moving-image artworks, music videos and photographs, often concerned with the experience of living in London and the politics of racial identity.

Shoes (2017) has the form of a music video but instead features a poem by spoken-word artist Sugar J (Jeremiah Brown), who both narrates and appears in the film. It opens with a panning view of a light breeze ruffling the trees and tall grasses of Wanstead Flats, a park in East London. Two figures are isolated in the landscape beside a lake. At the moment when their hands lightly touch, the poem starts. It reflects on the awkwardness and ambiguity of the way in which we express emotions through our bodies. In the same way that wearing a pair shoes the wrong way round would feel 'weird', sometimes the signals that our bodies 'disseminate into the world' fail to match the reality of our feelings.

'I'm interested in the interplay between the two masks that everyone wears... one in public and one in private.' [11]

[11] Conversation with the artist, March 2018

Sugar J's poem considers how the expectations and prejudices of Western culture can often exclude those who do not fit in to normative identities of race, gender or class. Govind's visual interpretation reflects on the racial politics that underlies the poem. Towards the end of the film, the central figure turns the back of his hands to the camera, revealing that they are painted white. The final image is a close-up shot of a glass of milk, a nourishing liquid but also what Govind describes as a symbol of whiteness.

C.F.

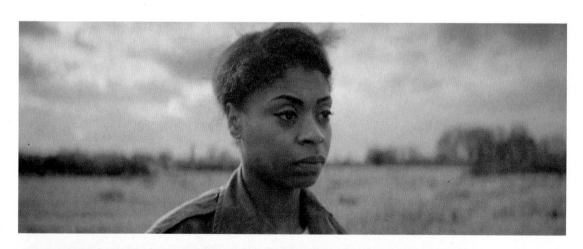

Richard Healy

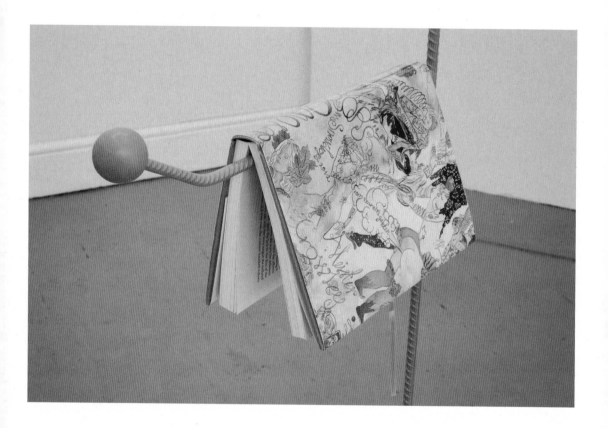

Snowdrops from a Curate's Garden (detail), 2016
powder-coated steel with book, wax candle, 205 × 40 × 59 cm

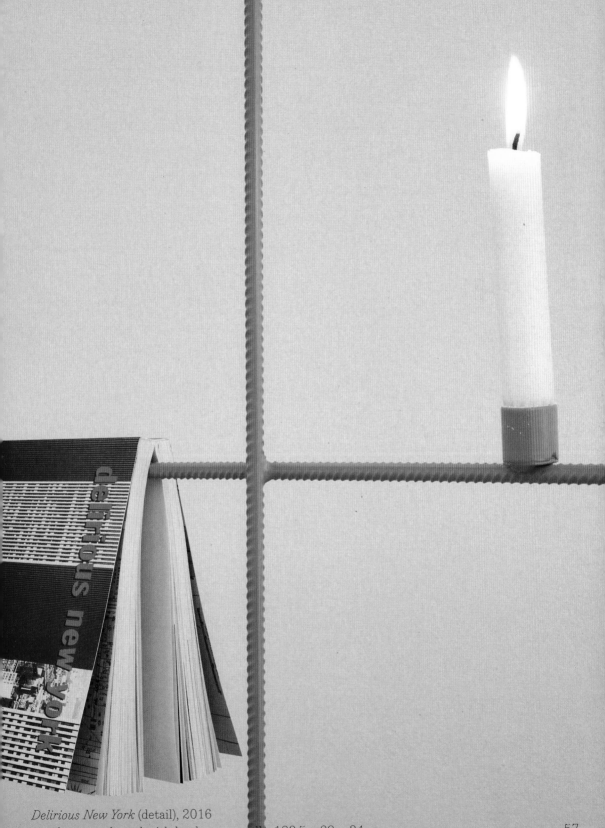

Delirious New York (detail), 2016
powder-coated steel with book, wax candle, 183.5 × 89 × 34 cm

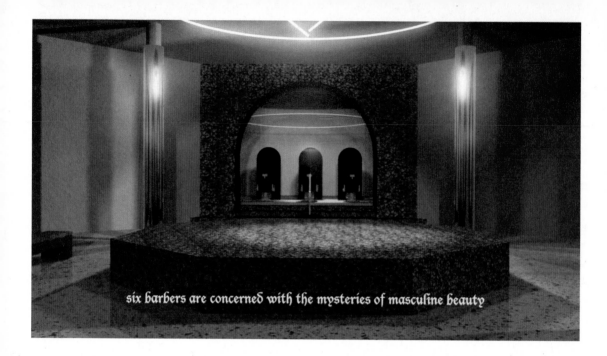

six barbers are concerned with the mysteries of masculine beauty

Richard Healy's work encompasses a range of media including video, sculpture, installation and print and often considers the relationship between art and design.

'Embodied through simulations of design, my practice frequently engages with digital technology as a means for artistic production and with it the acts of labour that are obscured beneath the finish.' [12]

[12] Artist's Statement, April 2018

In *Lubricants and Literature* (2016) a slick voice, as if from a developer's infomercial, guides us through a computer-generated luxury building. We start in a submarine basement with a Gothic dining room laid out for a feast. Then, up escalators and around corridors, we pass through marbled arcades, a boxing gym and pooled chambers whose props suggest gay male erotic possibilities.

We are led along just one of many possible paths through a fully rendered architectural model. The spaces are lit by gleaming purple-tinted neons shaped like arcane symbols.

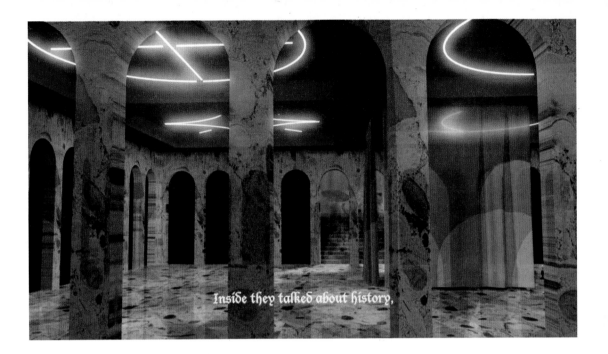

Inside they talked about history,

From bottom floor to top, these signs trace the 'fool's journey' of the tarot deck. Sometimes they are captured by the path of the camera, and sometimes they remain out of view. On the twelfth floor, an impossible panorama of the Manhattan skyline is fleetingly glimpsed, which our guide describes with phrases excerpted from *Delirious New York* (1978) by Rem Koolhaas.

The video and the group of sculptures that accompany it are partly inspired by an incident in the history of the famous esoteric bookshop Watkins Books, located in London's Cecil Court, across the street from the gallery where Healy first presented his work in 2016. In the 1930s, the controversial English occultist Aleister Crowley visited the proprietor John Watkins and reportedly pulled an extraordinary conjuring trick, making every single book on the shelves suddenly disappear and simultaneously reappear.

For his sculptures, Healy re-imagines this liminal point. Books are suspended from the narrow branches of curved steel lamp stands, seemingly levitating in mid-air, their pages spread open like wings. Purchased from shops along Cecil Court, the publications range from a recent issue of architectural journal *PIN-UP* to *Fighting Terms* (1954) by Thom Gunn, a poet known for his exploration of queer themes. Texts excerpted from these books are edited and spliced together to create the script for the video.

C.F.

Stills from *Lubricants and Literature*, 2016, HD video displayed on two plasma screens mounted on a single pole, 07:50 mins

Alexandr Serberov, 2017
enamel and oil on aluminium, 120 × 120 cm

Des Lawrence

Des Lawence works in text, drawing and painting using meticulous techniques to explore the possibilities of visual obituaries.

Lawrence takes his inspiration from recent newspaper obituaries celebrating British and international figures. The point of departure can be either a photographic portrait associated with the character, or his or her biography. His painstaking technique using oil and enamel paint is uncanny: seen at first glance, the paintings have a photographic precision, yet the longer you spend with them, the more apparent the careful colour scheme, the different planes and the construction of the work become.

'I'm unnaturally fixated on the microscopic subtlety of a surface.' [13]

In *Alexandr Serberov* (2017) two men gaze at the camera. The one on the right is Serberov, who died in 2013. He briefly held the record for the greatest number of spacewalks: ten. More importantly, the work refers to the Space Race and its aftermath spearheaded by the USSR and the USA during the 1960–80s, an era that marked Lawrence's youth. This interest in Cold War politics is also visible in *Vic Allen* (2017) which shows a framed picture of Erich Honecker hanging on a wall in Stasi headquarters acting as a proxy for Allen, the British academic accused of being an East German spy.

Similarly, *George Martin* (2016) focuses not on the fascinating biography of the man who helped produce and launched the music careers of the globally renowned Beatles, but on the state-of-the-art equipment used in studios where he would have worked during this period.

Women are too often discussed in terms of their personal biographies or relations to men, often accompanied by a portrait photograph. Lawrence's portrait of *Isabella Karle* (2018) represents a famous model of crystallography that influenced her pioneering work in chemistry rather than her image.

Lawrence offers alternative forms of history portraits: rather than being straightforward representations, they bring the genre into the digital era by focusing on visual associations, mirroring the infinite number of image search results that are now possible online.

E.B.

[13] 'Des Lawrence interview with Rob Colvin', *Hyperallergic*, 2014: www.hyperallergic.com/158132/artists-pick-artists-des-lawrence/

George Martin, 2016,
enamel on aluminium, 167 × 239 cm

Isabella Karle, 2018
enamel on aluminium, 22.8 × 30.3 cm

Vic Allen, 2017
enamel on aluminium, 53.5 × 48 cm

Tom Lock

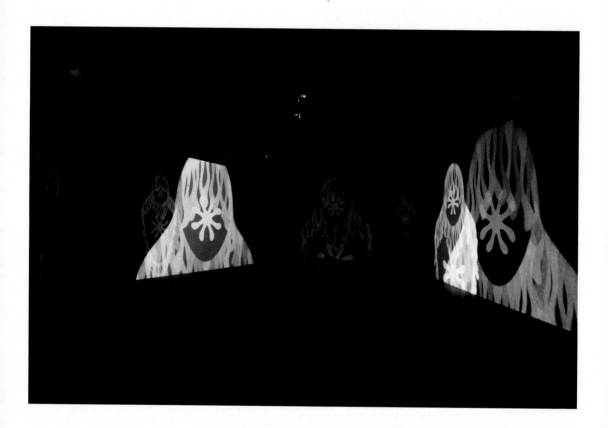

This page and overleaf: *Within*, 2017
four screen HD video and surround sound installation, 07:00 mins

Tom Lock works in animation and sound, drawing on literature to create multi-sensory landscapes.

Within (2017) is a large-scale video-installation whose forms draw inspiration from children's animations of the 1960s and 70s. These are hand-drawn by Lock, digitally animated then projected on four channels, offering an expansive and psychedelic landscape. An immersive audio track surrounds the viewer, with passages drawn from 'Dawn', the first story from the trilogy *Lilith's Brood* (1987) by the celebrated African-American science-fiction writer Octavia E. Butler.

The narrative imagines a future encounter with aliens, who warn the human race of their imminent self-destruction. In order to ensure the future of humanity, they shrewdly suggest interbreeding. They warn:

'You are an intelligent species; in fact, one of the most intelligent we have discovered, but you are hierarchical. You allow your intelligence to serve hierarchy, instead of guiding it. You do not realise how dangerous this is.'

In this text, notions of identity are questioned. Gender, race and human status are all explored through a series of ethical dilemmas. In order to survive, must humanity become hybrid and is this status preferable to extinction?

Lock extends the ideas explored in *Within* by collaborating with musicians on experimental performances. For *The London Open 2018*, he worked with musician Tom Richards, who designs and builds his own analogue synthe-sisers, to extend the visual and metaphorical possibilities of the piece using long-form and improvised sounds.

Through his exploration of fragmented sound, narrative and immersive visuals in collaboration with programmers, musicians and actors, Lock questions physical and metaphorical boundaries.

E.B.

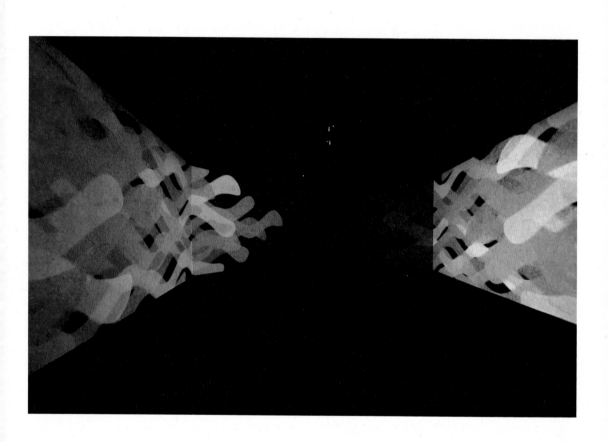

Tom Richards, *Maximum Overdrive Takeover*,
performance inside *Within*, Focal Point Gallery, 2 September 2017

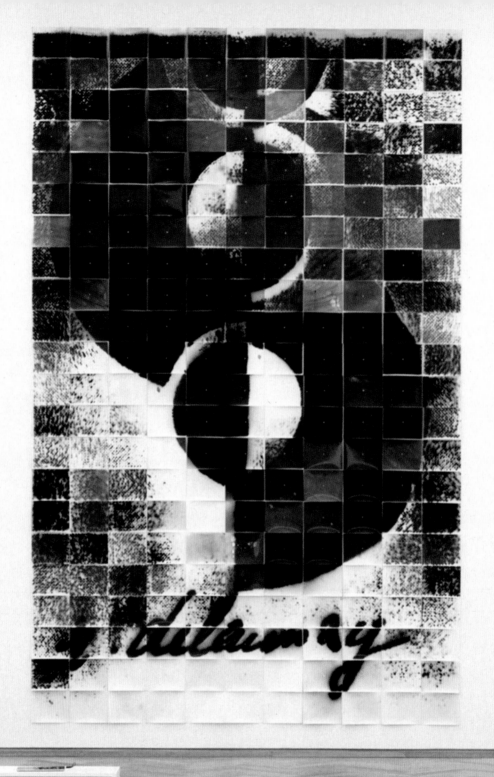

Céline Manz

Céline Manz works in a range of media exploring notions of copyright and authorship.

In the 1920s, the artist Sonia Delaunay created *Rythme Sans Fin*. This work inspired some of her own textile works but also her husband Robert Delaunay to create a series of studies called *Rythmes Sans Fin*. In 1956, after Delaunay's death, Sonia reproduced the studies as a series of stencils, adding his signature, and the works were illustrated in an associated exhibition catalogue. Its journey continues: in 1964 the *Situationist Times* published the motif without a signature in its journal, whose mission was to support collage, collaboration and solidarity with the disclaimer: 'all reproduction, deformation, modification, derivation and transformation of the *Situationist Times* is permitted.'

Technically, all these works are copyright infringements since they do not show 'original' artistic intent, i.e. they purposefully refer to the initial artwork. What happens, though, if the original is itself located in a copyright grey area? Who is the author of the motif: Sonia or Robert? Did he ever claim it as his? Is Manz authorised to reproduce the image from the *Situationist Times* if they allow her to 'derive' work from it, even though they are not the image's copyright holders? And given that her interpretation and conceptual project is so far removed from the intentions of the original piece, and is itself testing copyright boundaries, does it fall within the limits of an artist's 'fair use'?

E.B.

'To me, a picture is a tissue of quotations drawn from innumerable centers of culture... A picture's meaning lies not in its origin, but in its destination.' [14]

Manz tests the limits of copyright through her re-appropriation of the *Rythme Sans Fin* motif in a large-scale mural composed of individual photograms. She made each of the 242 prints by exposing light-sensitive paper to a computer screen. When assembled together the photograms represent the motif. Through this gesture, Manz turns the technologies of mechanical reproduction on their head by creating a personal and physical reproduction. She also cathartically produced a series of 1,832 versions of the motif on a variety of supports: stencils, linocuts, drawings on paper, towel, in gouache, in notebooks and adding her initials C.M.

[14] Céline Manz, 'The Triangular Nature of Desire' (text assembled from a series of interviews and artist's statements by Sherrie Levine, Sarah Charlesworth and Barbara Kruger), *Metropolis M Magazine*, Pictures Generation Issue, 2016

Rythme sans fin, Domaine Public, 2014—16, photographic installation consisting of 242 analogue photograms, 540 × 340 cm

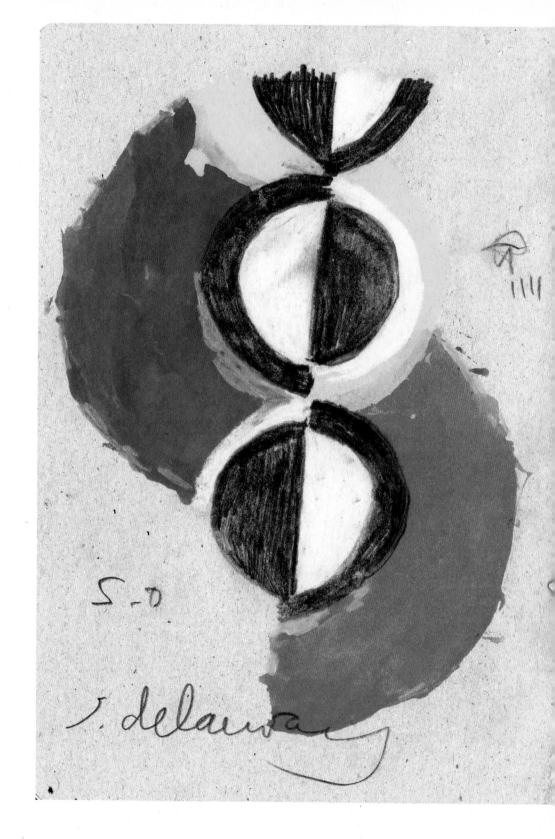

Rythme sans fin, No 1 – 1832 (detail), 2016
1832 drawings on various materials, dimensions variable

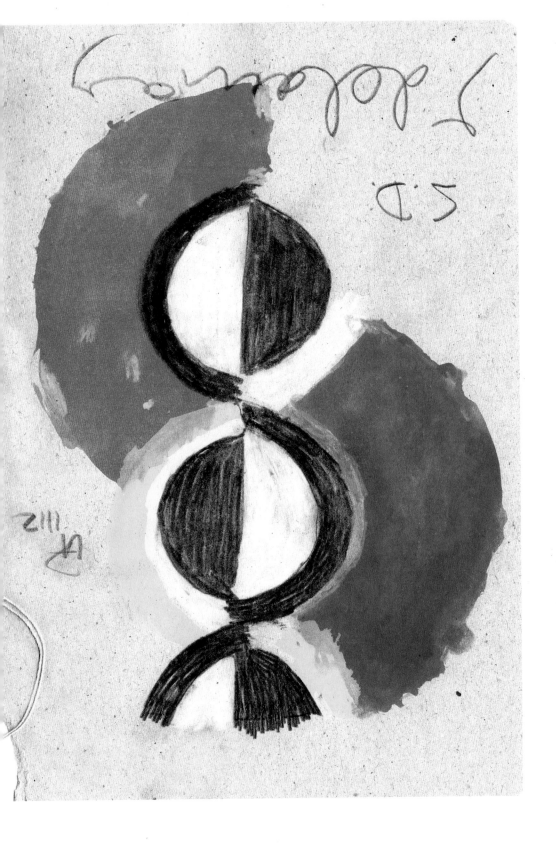

Uriel Orlow

Uriel Orlow works in film, photography, installation and sound, exploring social memory and blind spots of history.

Orlow presents four works from the *Theatrum Botanicum* series (2015—2018).

'Conventionally, we think of history as human history, as what we do, events that we cause or experience... So to me, it seems interesting to think about history not just from the point of view of humans, but also from a botanical perspective, considering plants as actors in and witnesses of history.' [15]

Grey, Green, Gold (2015—17) brings together a slide projection, a seed on a plinth with a loupe, a photographic wallpaper and a print. The work explores the parallel stories of the establishment of Nelson Mandela's garden on Robben Island where he was imprisoned during 1964—82, which also acted as a cache for his writings, and the development of the rare, yellow *Strelizia Reginae*, a bird of paradise plant, at Kirstenbosch, the South African National Botanical Gardens. The work considers national and botanical emancipation and how, in a strange twist of fate, the flower, now named Mandela's Gold, is threatened by an invasive squirrel initially introduced by the British colonist Cecil Rhodes..

[15] Uriel Orlow in Dimitrina Sevova, 'Interview with Uriel Orlow', *Corner College*, April 2017: www.materials.corner-college.com/2017/201704/ interview-uriel-orlow-by-dimitrina-sevova.html

Stills from *The Fairest Heritage*, 2016
HD video, 05:22 mins

The Fairest Heritage (2016—17) is a digital slide projection featuring footage not seen since 1963 from the Kirstenbosch jubilee celebrations, featuring white 'national' dances and crude pantomimes about conquests. Orlow has invited performer Lindiwe Matshikiza to inhabit the footage, her gestures offering a confrontation with a whitewashed botanical history.

The series *Memory of Trees* (2016—17) celebrates trees as silent witnesses of history. *The Lombardy Poplar, Johannesburg* was a landmark for apartheid opponents as they came to find refuge at Ruth Fischer's safe house, daughter of Braam Fischer, a prominent SA Communist Party member. By printing the work in black and white reverse positive, Orlow highlights the visual and historical aura of the location.

Imbizo Ka Mafavuke (Mafavuke's Trial) (2017) is an experimental film recording the preparations for a people's tribunal bringing together traditional healers, activists and lawyers to discuss indigenous plant knowledge and bio-prospecting by pharmaceutical companies. At stake are questions of plant knowledge and copyright protection. The weight of history is felt as the ghosts of colonial explorers, botanists and judges look on.

E.B.

Lombardy Poplar, Johannesburg from the series
The Memory of Trees, 2016, black and white photograph, 150 × 120 cm

Rachel Pimm

Hardcore Deposition, 2017, billboard print mounted
on 3 powder coated steel and chipboard units, 178 × 270 cm

Diagenetic Sequence Shelf (detail), 2017, set of 3 powder coated steel and chipboard units,
ceramics, silica, digital prints on blue-back and fabric, adhesive, 178 × 270 × 45 cm

Stills from *Resistant Materials: Part One*, 2017
HD video, sound, 07:18 mins

Rachel Pimm works in a range of media including film, photography and sculpture to explore the materiality of our environment.

Resistant Materials is an installation including a video that captures the various manufacturing stages of high-end curved glazed ceramic tiles used in building and interior design projects. It follows the push and pull of the organic materials as they are processed through various machines or finished by hand, from the extraction of raw minerals and the shaping of unfired clay, to its glazing and firing and the meticulous finishing or rejection. The video is complemented by an upbeat, gooey soundtrack – music that played at the manufacturing plant Dtile in which Pimm filmed.

Pimm explores both the skills and shortfalls of these high-end material processes. While architectural utopias of the 1960s aimed to create global superstructures, this tiling manufacturer, Dtile, aims to clad any surfaces, their motto being 'we tile the world'. Here Pimm explores the allure of these perfect white tiles and their possibilities to create a perfect infinite grid even over curved surfaces, but also the tension inherent in the materials as they resist being curved into a shape or smoothed to create a perfect finish. Indeed, a large percentage of these tiles are discarded, as can be seen in the wall-based print capturing the pile of rejects.

'I have been thinking for a while about the stuff of the world, almost working through it one material at the time, which feels limitless in an exciting way.' [16]

[16] 'Interview with Rachel Pimm', May 2017 http://www.spacestudios.org.uk/art-technology/interview-with-rachel-pimm/, May 2017

Part of a generation of artists who are exploring humanity's irreversible impact on the environment, Pimm's work often opens up a space for reflection on non-human agents such as mineral, biological or manufactured elements, in this instance to consider material, ecological and economic resistance.

E.B.

Renee So doesn't give much away in her work; she invites the viewer to weave together a pattern of cultural references. Through tongue-in-cheek humour she bestows both monumental grandeur but also caricatural qualities to the characters that comprise her groups of works.

Sunset (2016), a handmade square-format tapestry, shows two pairs of booted male legs that could be either cartwheeling or high-kick dancing. The tension between the two figures, perhaps engaged in a display of talent, virility or attraction, appears to climax in a bright red sun in the top-right corner of the work.

This exploration of male sartorialism continues with So's ceramic Boot (2016) a light-hearted, almost irreverent portrait of a man as a cut-out boot. She often translates initial sketches or line drawings into a finished ceramic form, underlining its cartoon qualities and also the constructed nature of the world around us.

A new series of works, Reliefs (2018), includes an array of bearded men, which often populate So's artistic imaginary, their features frequently obscured by their stylised facial hair. Reminiscent of ancient Assyrian bas-reliefs, or the bearded Bellarmine figures on medieval drinking jugs, or even seventeenth-century Chinese representations of Western curly hair or wigs, the work offers a journey through art history.

The human figure is both central and almost erased from So's work. The precision employed in the finish of the work – in wool or clay – is paralleled by the exploration of the limits of cross-cultural stylistic purity.

E.B.

'The craft element of my work is integral and inherent in everything I make — it informs my choice of materials which also determines what I can and cannot do with these materials. I don't feel I need to downplay or even highlight the techniques used in my work, it's just the foundation of it, and I try to build on that to create something personal and unique to me.' [17]

[17] Renee So in Monica Khemsurov, 'Studio Visit with Renee So', Sight Unseen, 2012: www.sightunseen.com/2012/11/renee-so-artist/

Woman, 2018
Ceramic, 46 × 29 × 20 cm

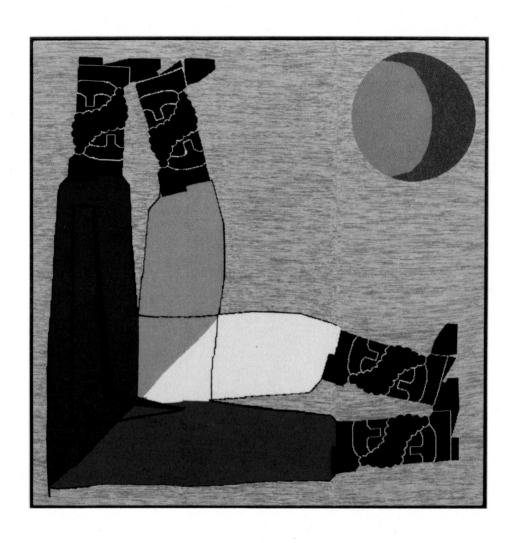

Sunset, 2016
knitted synthetic fibre, 150 × 150 cm

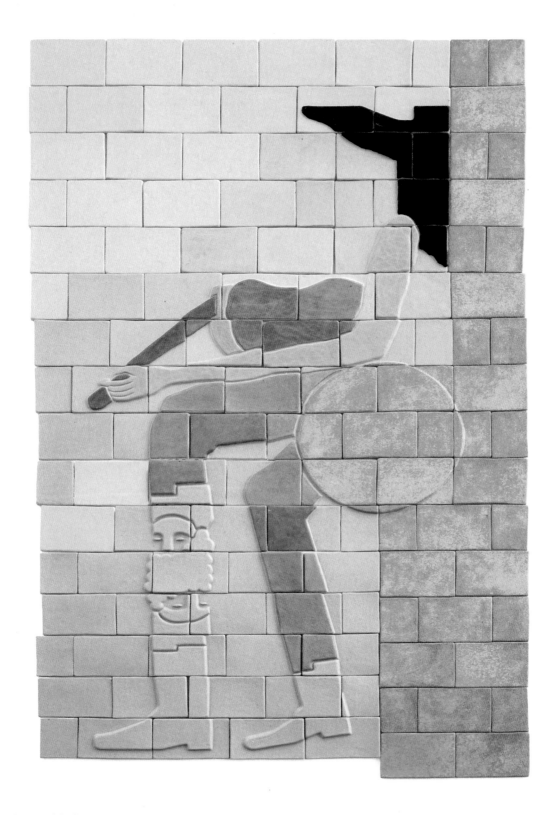

Guitar, 2018
glazed ceramic, oil paint, 150 × 90 cm

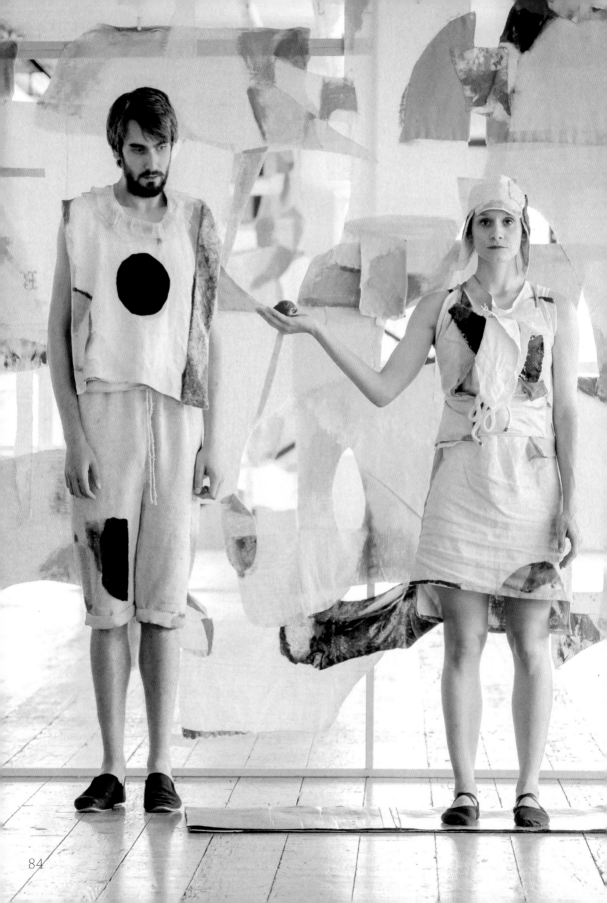

Alexis Teplin

Alexis Teplin is a painter whose practice expands beyond the limits of the frame, to include writing, performance, costume and at times, moving image.

Her work is informed by early twentieth-century abstraction, from Wassily Kandinsky to Sonia Delaunay. Colour precedes form, alongside a painterly relationship to sound and movement. Her precisely staged performances usually take place in front of, or in relation to, one of her paintings. Actors recite scripts composed of Teplin's own writings, interwoven with fragments collected from an eclectic array of sources including BBC Radio 4 and the works of Doris Lessing. Costumes designed by the artist and worn by the performers are an extension of the canvas; it appears as if these figures have emerged from the very fabric of the painting itself.

Arch (2016), first shown at the 20th Biennale of Sydney in 2016, specifically takes its gestural references from Indian street theatre, 1960s Hollywood films and the traditions of Russian abstract theatre. Performed by three actors in three acts, the painting's large metal stretchers become a spatial divider that also creates a physical container for the narrative. In the text itself we are met by both a density of language and an absurdity of juxtapositions.

By obscuring the signifiers of the appropriated image, text, sound and gesture, Teplin critically blurs the boundaries of high and low culture in a way that is uneasy and mesmerising in equal measure.

J.S.

Arch (The Politics of Fragmentation), 2016
performance at the 20th Biennale of Sydney

A partridge and a peacock
both sink their tails are
too heavy.

Up like a sun

Arch, 2016, oil paint and pigment on linen,
metis linen, velvet and canvas, 512 × 284 × 60 cm

down like a pancake.

I like a digestive,
they're very delicious.

Elisabeth Tomlinson

This page and following spread:
Stills from the series *William*, 2017—18
HD video, sound, 11:36 mins

Feminist political movements have highlighted how media and artistic representations of women are structured by unequal power relations. Elisabeth Tomlinson reverses and subverts the all-too-familiar male vision of women's bodies by presenting her own intimate female perspective on desire, the male body and vulnerability.

An ongoing series of films features a number of men who are invited into her most private space, her bedroom. Filmed over the course of several visits, they are simply encouraged to converse and share their intimate thoughts. Any sense of time is suspended when Tomlinson edits the footage from these candid encounters into short films, ranging from 30 seconds to 4 minutes long. She aims to capture moments that express the 'contradictions, insecurities, beauty, tenderness and vulnerability' of her male subjects. This process of editing and display complicates the hierarchy of viewer and viewed.

On display in *The London Open* is a series of three films featuring the subject William, who is shown naked and reclining on her bed. In the first film, he discusses themes around sexuality and pleasure, the second focuses on his self-consciousness and insecurities, while the final film is concerned with his intimate relationships with women. While this man is the only person who appears in the film, we are always made aware that a woman is behind the camera.

'[The work is] *about women... but rather than what we look like, it is what we look at. Women are so often the object of desire, but I'm depicting a reality where women are the possessors of desire.'* [18]

C.F.

[18] Artist's Statement, November 2017

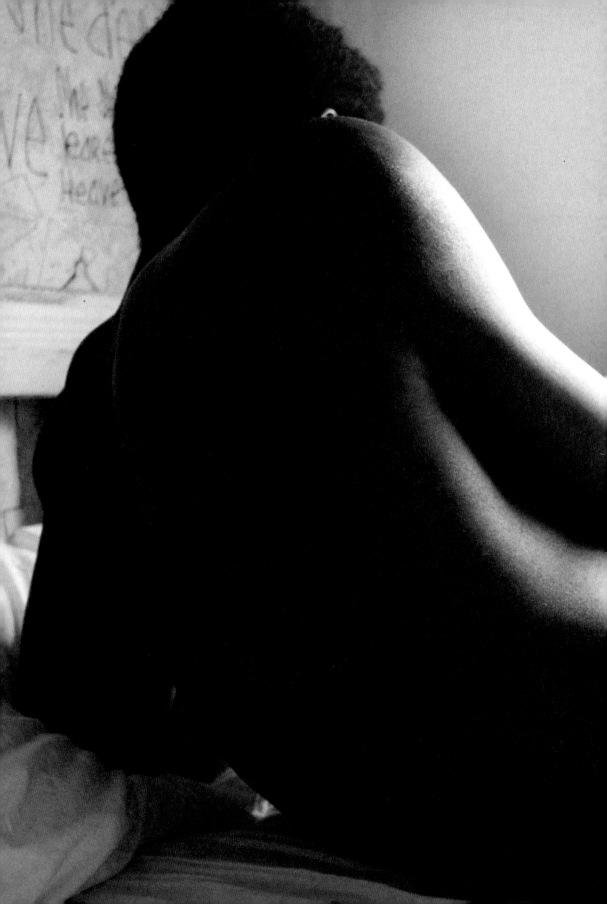

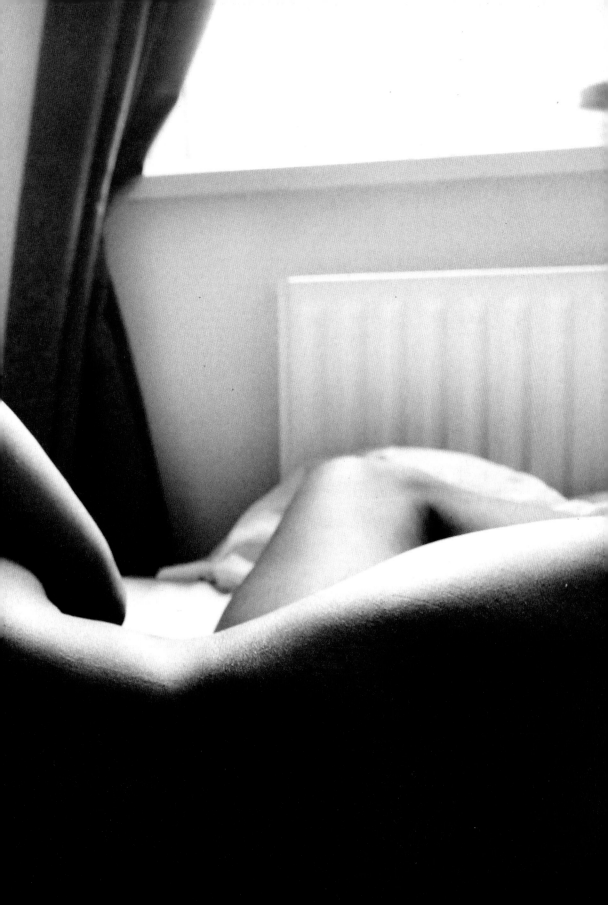

Study for *Illovo Lamp,* 2018
ink and crayon on paper, 29.7 × 21 cm

Jonathan Trayte

Study for *Bosobolo*, 2018
ink and crayon on paper, 29.7 × 21 cm

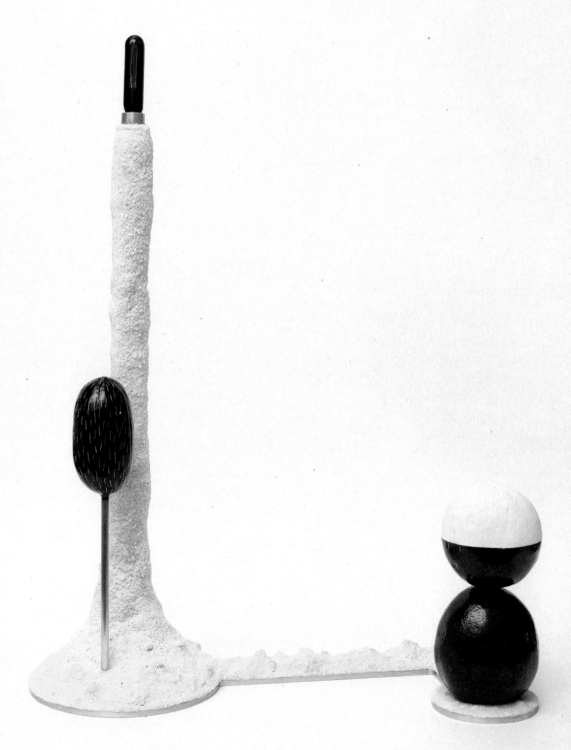

Jonathan Trayte uses elements as diverse as
painted bronze, freely formed neon and concrete
casts of enormous vegetables.

'[My work] *reinterprets modern consumer behaviour
and explores the psychology of desire through
surface, material and light.*' [19]

[19] Jonathan Trayte in 'Jonathan Trayte:
Switched On', *AMBIT*, Issue 230,
Autumn 2017, p.28

Intrigued by his works' associations with craft
and furniture-making processes, Trayte has
made sculptures for *The London Open 2018*
that operate as functional lamps. These five
newly constructed works are clustered into two
families. As part of his research for this ongoing
series, Trayte makes use of a vast archive of
packaging from an array of global food cultures,
which provide sources for bright synthetic colour
combinations and suggestive motifs. Perhaps
a frankfurter from the label of an American
jar or a palm tree adapted from a box of coconut
macaroons will be transformed and reimagined
as an arrangement for a sculpture.

While Trayte's initial designs can be
playful and spontaneous, his sculptures are
realised using techniques from industrial design
and production that require an extraordinary
level of detail and planning. Their solid stainless
steel bases are waterjet cut and fittings for
complex, delicate neons are welded and
threaded so that they attach precisely.

C.F.

Bau Bau Bar, 2018, painted bronze, stainless steel, foam, polymer plaster,
adhesive, pigments, fused silica, crushed marble, light fitting, 98 × 78 × 30 cm

Tom Varley

Tom Varley's recent work examines the limitations and possibilities of new communication technology and how it is changing the way in which individuals, governments and corporations interpret reality.

'I'm interested in the over-interpretation of data, in random correlations between phenomena mistaken for causal relationships, in spider-diagrams and conspiracy theories.' [20]

In the first part of a yet-to-be completed film trilogy titled *The Eccentricity of an Ellipse* (2016) Varley focuses on the recent Rosetta mission initiated by the European Space Agency (ESA), which in late summer 2014 ventured into the orbit of comet 67P/Churyumov–Gerasimenko. The Rosetta probe carried a smaller spacecraft called Philae, which was designed to be the first man-made object to land on the surface of a comet.

[20] Artist's Statement, March 2018

This page and following spread: stills from *The Eccentricity of an Ellipse: Part One*, 2016 HD Video with sound, 08:39 mins

The film opens with a simple linear shape that expands and contracts from a line to a circle and back. A series of black and white film clips follow: a close-up view of a washing machine, a cup of black coffee seen from above, footage of a fizzing pill being dropped into a glass of water reversed so that it appears to leap back into the grasp of a finger and thumb.

Alongside these evocative images, a script narrated by Varley reflects on the marketing strategies that the ESA employed to communicate significant moments in the Rosetta mission. Twitter accounts were set up in the names of the two spacecraft in an attempt to make them appear more human-like and relatable. The space agency even created cartoon versions of them, with Philae as 'a loveable child-like character with an "I ♥ Earth" sticker on its backpack.' Varley imagines the existential dilemmas these characters might face after their mission has ended, the landed Philae probe abandoned and disintegrating on the hostile surface of the icy comet.

C.F.

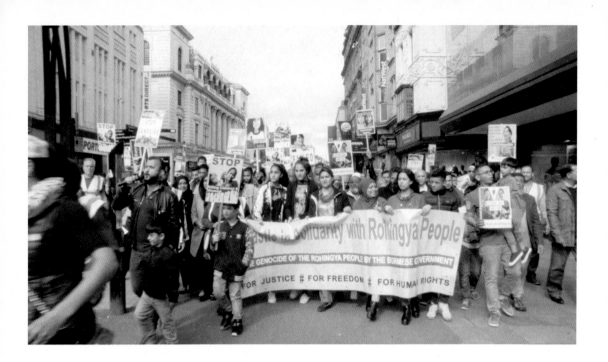

'[Filmmaker Pedro Costa] *has talked about how there remains a gap between those in front of the camera and those behind, as there is between people in day-to-day existence. And it is in this space, between, that the possibilities arise; opportunities for identification, for compassion, for empathy, and a chance to challenge the tired clichés of encounter; ... without a space there can be no observation and meeting with the 'other', and therefore, no means for empathy.'* [21]

Still from *Civil Rites*, 2017
film, 28:00 mins

Andrea Luka Zimmerman

A co-founder of Vision Machine and Fugitive Images, Andrea Luka Zimmerman is an artist and cultural activist who works individually and collaboratively in film, installation and photography, exploring the intersection of public and private memory, in particular in relation to structural and political violence.

Civil Rites (2017) explores the rich history of resistance and activism in Newcastle, going back to 1633 and including the city's vigorous support of abolitionism during the nineteenth century. The film takes as a point of departure Martin Luther King's honorary doctorate acceptance speech at the University of Newcastle in 1967, examining how the themes central to King's speech are still as relevant in the current political climate: poverty, racism and war continue to affect our lives.

The film unfolds across the course of a day in the locations of significant demonstrations in the city. A narrative soundtrack is drawn from a series of interviews with local activists. Audio and visuals run parallel or come together at times, weaving a rich tapestry of connections around the socio-political history of Newcastle.

The display includes a series of protest posters and materials gathered from individual and local archives, widening the focus to London and other UK cities. Through a series of associated events, the artist explores campaigns for social change. These include readings by Refugee Tales, an organisation which highlights the human rights of asylum seekers, as well as artists and writers to read seminal texts from May '68 on the fiftieth anniversary of this social uprising.

E.B.

[21] Andrea Luka Zimmerman, 'On common ground: the making of meaning in film and life', *openDemocracy*, 3 October 2013: https://www.opendemocracy.net/andrea-luka-zimmerman/on-common-ground-making-of-meaning-in-film-and-life

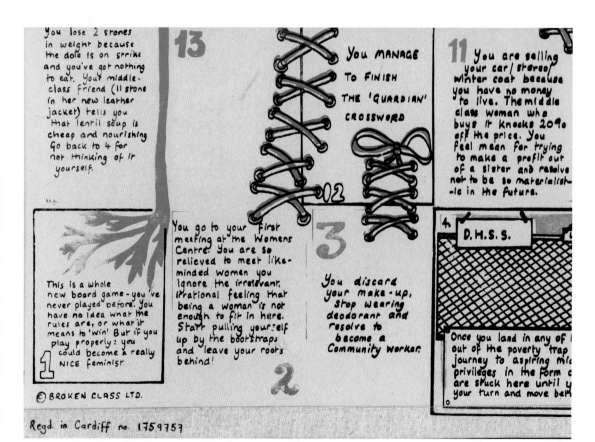

You lose 2 stones in weight because the dole is on strike and you've got nothing to eat. Your middle-class friend (11 stone in her new leather jacket) tells you that lentil soup is cheap and nourishing. Go back to 4 for not thinking of it yourself.

13

You MANAGE TO FINISH THE 'GUARDIAN' CROSSWORD

11 You are selling your car/stereo/winter coat because you have no money to live. The middle class woman who buys it knocks 20% off the price. You feel mean for trying to make a profit out of a sister and resolve not to be so materialist-ic in the future.

This is a whole new board game - you've never played before. You have no idea what the rules are, or what it means to 'win'. But if you play properly you could become a really NICE feminist.

1

© BROKEN CLASS LTD.

You go to your first meeting at the Womens Centre. You are so relieved to meet like-minded women you ignore the irrelevant, irrational feeling that being a woman is not enough to fit in here. Start pulling yourself up by the bootstraps and leave your roots behind!

3

You discard your make-up, stop wearing deodorant and resolve to become a Community worker.

2

4 D.H.S.S.

Once you land in any of out of the poverty trap journey to aspiring mic privileges in the form c are stuck here until y your turn and move be

Regd. in Cardiff no. 1759757

Poet, playwright and writer Inua Ellams reading for Refugee Tales
in front of quilt made by Gatwick Detainees Welfare Group

LIST OF WORKS

LARRY ACHIAMPONG
PAN AFRICAN FLAG FOR THE RELIC TRAVELLERS' ALLIANCE (MOTION), 2018, printed banner, 392.5 × 110 cm

Relic 1, 2017, single channel 4k video with stereo sound, 14:12 mins

RACHEL ARA
This Much I'm Worth (The self-evaluating artwork), 2017, 83 pieces of neon, recycled server room equipment, electronics, computers, IP cameras, programming, 420 × 160 × 90 cm

GABRIELLA BOYD
Draft, 2018, oil paint on canvas, 145 × 89 cm

The Optimist, 2018, oil paint on canvas, 50 × 40 cm

Tomorrow Started, 2018, oil paint on linen, 126 × 101 cm

HANNAH BROWN
Hedge 3, 2017, oil paint on linen, 121 × 171 cm

The field next to Tesco that is soon to be built on 1, 2016—17, oil paint on marine plywood and oak, 36 × 46 cm

Victoria Park 12, 2016, oil paint on marine plywood and oak, 32 × 40 cm

Washford Pyne 11, 2016, oil paint on linen, 150 × 200 cm

RACHAEL CHAMPION
Blackwall Reach, 2018, demolition rubble, digital print on wallpaper over timber frame, urban plants, dimensions variable

GARY COLCLOUGH
New Seeker, 2017, oil paint on birch plywood panel, teak, 160.5 × 120 × 120 cm

Once Taken, 2017, oil paint on birch plywood panel, teak, 21 × 115 cm

Outside in the New Light, 2017, oil paint on birch plywood panel, linen, teak, 85.5 × 95.5 cm

Three Peaks, 2017, oil paint on birch plywood panel, teak, 140 × 165; 126 × 140; 112 × 131 cm

GEORGE EKSTS
Bonfire, 2017, acrylic paint on panel, brass, 40.5 × 39.5 cm

Knots, 2017, inkjet print, drawing on panel, 62.2 × 38.5 cm

Parables, 2018, drawing and collage on paper, 119 × 58 cm

Rehearsal, 2017—, HD video with sound, 04:00 mins

Wild Service, 2018, print on vinyl, 430 × 220 cm

AYAN FARAH
RA—Hammar, 2018, indigo, linen, 200 × 150 cm

Waris—Indigo, 2018, clay, Dead Sea mud, indigo, India ink and carob on linen, 200 × 150 cm

Zizi Oasis, 2018, clay, cloud seeded rainwater, linen, dimensions variable; linen: 190 × 60 cm

VIKESH GOVIND
Shoes, 2017, HD video, sound, 03:40 mins

RICHARD HEALY
Delirious New York, 2016, powder-coated steel with book, electric candle, 183.5 × 89 × 34 cm

Lubricants and Literature, 2016, HD video displayed on two plasma screens mounted on a single pole, sound, 07:50 mins

PIN-UP, 2016, powder-coated steel with magazines, electric candle, 36 × 65 × 100 cm

Queer Spirits, 2016, powder-coated steel with book, electric candle, 26 × 34 × 38 cm

Snowdrops from a Curate's Garden, 2016, powder-coated steel with book, wax candle, 205 × 40 × 59 cm

DES LAWRENCE
Alexandr Serberov, 2017, enamel and oil paint on aluminium, 120 × 120 cm

George Martin, 2016, enamel on aluminium, 167 × 239 cm

Isabella Karle, 2018, enamel on aluminium, 22.8 × 30.3 cm

Vic Allen, 2017, enamel on aluminium, 53.5 × 48 cm

TOM LOCK
Within, 2017, four screen HD video and surround sound installation, 07:00 mins

CÉLINE MANZ
Rythme sans fin, domaine public, 2014—16, installation comprising 242 analogue photograms, overall: 540 × 340 cm

Rythme sans fin, No 1, 2016, selection from 1832 drawings on various materials, overall dimensions variable

FRENCH & MOTTERSHEAD
Grey Granular Fist, 2017, chair, sensor, audio player, headphones, audio (Set of 3), 24:00 mins

Homebody, 2018, audio, online broadcast, approx. 23:00 mins

URIEL ORLOW
The Fairest Heritage, 2016, HD video, sound, 05:22 mins

Grey, Green, Gold, 2015—16, wallpaper with slide projector, plinth, seed, magnifying glass, photographs on aluminium, framed photograph, overall dimensions variable

Lombardy Poplar, Johannesburg from the series *The Memory of Trees*, 2016, black and white photograph, 150 × 120 cm

RACHEL PIMM
Diagenetic Sequence Shelf, 2017, set of 3 powder coated steel and chipboard units, ceramics, silica, digital prints on blue-back and fabric, adhesive, 178 × 270 × 45 cm

Hardcore Deposition, 2017, billboard print mounted on 3 powder-coated steel and chipboard units, 178 × 270 cm

Resistant Materials: Part One, 2017, HD video, sound, 07:18 mins

RENEE SO
Boot, 2016, glazed ceramic,
32 × 42 × 15 cm

Guitar, 2018, glazed ceramic, oil paint,
150 × 90 cm
Sunset, 2016, knitted synthetic fibre,
150 × 150 cm

Woman, 2018, ceramic,
46 × 29 × 20 cm

ALEXIS TEPLIN
Arch, 2016, oil paint and pigment on
linen, metis linen, velvet and canvas,
512 × 284 × 60 cm

Costumes for A and B, oil paint and
pigment on linen, metis linen, velvet
and canvas, steel, 80 × 180 × 40 cm

ELISABETH TOMLINSON
William's Proof, 2017, HD video,
sound, 2:58 mins

William's Hair, 2018, HD video,
sound, 2:00 mins

William's Hesitations, 2018, HD video,
sound, 2:20 mins

JONATHAN TRAYTE
Bau Bau Bar, 2018, painted bronze,
stainless steel, foam, polymer
plaster, adhesive, pigments, fused
silica, crushed marble, light fitting,
98 × 78 × 30 cm

Bosobolo, 2018, painted bronze,
stainless steel, foam, polymer plaster,
adhesive, pigments, flock, neon, light
fitting, 60 × 80 × 30 cm

Illovo Lamp, 2018, painted bronze,
stainless steel, polymer plaster,
adhesive, pigments, fused silica,
hide, crushed marble, light fitting,
94 × 52.5 × 34 cm

Mint Float, 2018, painted bronze,
stainless steel, foam, polymer plaster,
adhesive, pigments, flock, crushed
granite, neon, 110 × 72 × 30 cm

Sugarloaf, 2018, painted bronze,
stainless steel, foam, polymer plaster,
adhesive, pigments, flock, neon,
90 × 56 × 26 cm

TOM VARLEY
The Eccentricity of an Ellipse: Part One,
2016, HD video, sound, 9:20 mins

ANDREA LUKA ZIMMERMAN
Civil Rites, 2017,
film, sound, 28:00 mins

Collection of posters and banners from
London activist groups, 1970—present,
dimensions variable

Pat Garrett and Jackie Collins,
Roots and Bootstraps, c.1980—85,
board game, 64 × 52 cm, collection
of Pat Garrett

Selection of books published in the
year 1968, including those suggested
by Aysen Denis, Evan Ifekoya, Juliet
Jaques, So Mayer, Liberty Antony
Sadler, Daniella Shreir and the artist.

LONDON OPEN LIVE

AN EVENING OF PERFORMANCE
Thursday 14 June
Featuring live works by Larry
Achiampong, Tom Lock, Rachel Pimm
and Alexis Teplin

URIEL ORLOW
Thursday 21 June
London premiere of Uriel Orlow's
film *Imbizo Ka Mafavuke (Mafavuke's
Tribunal)*, followed by a discussion
between Uriel Orlow, Emily Pethick
and Shela Sheikh

REFUGEE TALES
Wednesday 11 July
The Refugee Tales project, which
walks in solidarity with refugees,
asylum seekers and detainees,
will pause at the gallery to recite
articles from the Universal
Declaration of Human Rights,
marking its 70th anniversary

ANDREA LUKA ZIMMERMAN
Saturday 21 July
Readings from books published
in 1968, organised by Andrea
Luka Zimmerman and selected
by Aysen Denis, Evan Ifekoya, Juliet
Jaques, So Mayer, Liberty Antony
Sadler, Daniella Shreir and the artist

ARTISTS' BIOGRAPHIES

LARRY ACHIAMPONG
b. 1984, London, UK
2008 MA Sculpture, Slade School
of Fine Art, London
2005 BA (Hons) Mixed Media Art,
University of Westminster,
Middlesex
Selected exhibitions, screenings
and performances: *3-Phase: We Can't
Float Here*, WORKPLACE, Gateshead
(2018); *Larry Achiampong: Pan African
Flag for the Relic Travellers' Alliance,*
Somerset House, London (2017–18)
(solo); *Diaspora Pavilion: 57th Venice
Biennale*, Palazzo Pisani a Santa
Marina, Venice, Italy (2017); *Finding
Fanon*, Tyneside Cinema, Newcastle
(2016) (solo); *Histories of a Vanishing
Present: A Prologue*, The Mistake Room,
California, USA (2016); *London Film
Festival (Experimenta: Second Sight)*,
British Film Institute, London
(2015); *Diaspora*, Victoria and Albert
Museum, London (2015); *Collections
of Collections*, Victoria and Albert
Museum, London (2014); *Digital Africa
('Africa Utopias')*, Southbank Centre,
London (2014); *Project Visible*, Tate
Modern, London (2013); *Disruption*,
Royal College of Art, London (2013);
*Larry Achiampong: MEH MOGYA
(SAMPLE OF ME)*, The Showroom,
London (2011) (solo); *Live Weekends:
Shunt*, Institute of Contemporary Arts,
London (2011); *Late at Tate Britain:
Afrodizzia*, Tate Britain, London (2010)

RACHEL ARA
b. 1965, Jersey, Channel Islands
1998 BA (Hons) Fine Art,
Goldsmiths College, London
1996 Foundation in Fine Art & Design,
City Lit, London
Selected exhibitions and screenings:
*American Beauty (a Trump L'oeil) feat.
Kay Le Seelleur Ara,* Barbican, London
(2018) (solo); *V&A, Codes & Secrets
(Friday Lates)*, Victoria and Albert
Museum, London (2018); *V&A Digital
Futures*, Hackney House, London (2017);
Anise Gallery, London (2017); *Aesthet-
ica Art Prize 2016 Exhibition*, York St
Mary's, York (2016); *The Lumen Prize
Global Tour*, London, Wales, Shanghai,
New York (2016); *7 Deadly Virtues*, Fish
Factory Arts Space, Falmouth (2016);
Pulling It Off, Fish Factory Arts Space,

Falmouth (2015); *Anonyme Zeichner*,
Galerie Nord, Berlin (2015)

GABRIELLA BOYD
b. 1988, Glasgow, UK
2017 Postgraduate Diploma,
Royal Academy Schools, London
2016 Exchange programme,
Kunstakademie, Düsseldorf
2011 BA (Hons) Fine Art, Glasgow
School of Art, Glasgow
Selected exhibitions: *Help Yourself*,
Blain|Southern, London (2018)
(solo); *Dreamers Awake*, White Cube
Bermondsey, London (2017);
Royal Academy Schools Show, Royal
Academy, London (2017); *John Moores
Painting Prize*, Walker Art Gallery,
Liverpool (2016); *East London Painting
Prize*, Nunnery Gallery, London (2014);
Other Places, The Old Fire Station,
Oxford (2013); *Sao Paulo International
Art Fair*, Pavilhão Ciccillo Matarazzo
2222 (2013); *Beijing International Art
Biennale*, National Museum of China
(2012), *Summer Exhibition*, Royal
Academy, London (2012); *Creative Cities
Collection*, Barbican, London (2012);
New Sensations Saatchi and Channel 4,
Victoria House, London (2011)

HANNAH BROWN
b. 1977, Salisbury, UK
2006 MA Sculpture, Royal College
of Art, London
2003 PGCE Art and Design (14–19),
Institute of Education, London
1999 BA (Hons) Fine Art Sculpture,
Central Saint Martins, London
1996 Foundation Art and Design,
Exeter College, Devon
Selected exhibitions and screenings:
Nocturnes, Cross Gallery, Dublin
(2017) (solo); *Lain Fallow for too Long*,
dalla Rosa Gallery, London (2017)
(solo); *The Arborealists: The Art of Trees*,
Bermondsey Project Space, London
(2017); *Marmite Painting Prize 2016*,
Block 336, London and Highlanes
Gallery, Ireland (2016); *A Lane to the
Land*, 71 Blandford Street, London
(2015) (solo); *The Winter Girls*, Milton
Keynes Arts Centre, Milton Keynes
(2015) (solo); *John Moores Painting
Prize*, 2012, Walker Art Gallery,
Liverpool (2012); *Encounter*, Gallery
Primo Alonso, London (2010) (with
Gary Colclough); *Hannah Brown*,
Gimpel Fils, London (2006) (solo)

RACHAEL CHAMPION
b. 1982, New York, USA
2010 Postgraduate Diploma, Royal
Academy Schools, London
2004 BA (Hons) Visual Art and
Sculpture, SUNY Purchase,
New York
Selected exhibitions: *Discoverers
of Onkalo*, Zabludowicz Collection,
Sarvisalo, Finland (2017) (solo);
New Spring Gardens, Chelsea Fringe
Festival: Nine Elms on the South
Bank, London (2016) (solo); *Rachael
Champion, Agnes Denes, Rachel Pimm*,
Hales'Gallery, London (2015);
Graphics Interchange Format, Focal
Point Gallery, Southend-On-Sea
(2015); *Primary Producers*, Hales
Gallery (2014) (solo); *Architecture
of Enjoyment: Fokidos 21*, Marcelle
Joseph Projects, Athens, Greece
(2014); *Dual Spectrum Subsistence*,
The Yard, Modern Art Oxford (2012)
(solo); *This Monster This Thing*, Focal
Point Gallery, Southend-On-Sea
(2012); *Implications for Productivity*,
The Old Police Station, London
(2010) (solo)

GARY COLCLOUGH
b. 1977, Exeter, UK
2009 MA Fine Art, Central Saint
Martins, London
1999 BA (Hons) Fine Art,
Chelsea College of Art, London
Selected exhibitions: *Neither From
Nor Towards*, Art Seen, Nicosia,
Cyprus (2017) (solo); *Choreography
of Fragments*, La Galerie Particulière,
Paris, France (2017) (solo); *Material
Symmetry*, William Benington Gallery,
London (2015) (solo); *Other Worldly*,
dalla Rosa Gallery, London (2014)
(solo); *Jerwood Drawing Prize*, Jerwood
Space, London (2013); *Earth Works*,
P.P.O.W. New York (2012); *Pulp Fictions*,
Transition Gallery, London (2011);
Encounter, Primo Alonso Gallery,
London (2010) (with Hannah Brown)

GEORGE EKSTS
b. 1978, London, UK
2011 MA Printmaking,
Royal College of Art, London
2002 BA Photography,
Falmouth College of Art, Falmouth
Selected exhibitions: *Casual Cursive*,
Sidney Cooper Gallery, Canterbury
(2015) (solo); *Development Heaven*,
University of Herts Art & Design
Gallery, Hertfordshire (2015) (solo);

Cause Unknown, Tintype, London (2014) (solo); *Pitch, Roll, Yaw*, Toulouse International Art Festival, Toulouse, France (2013) (solo); *Incredible Utility*, Hayward Gallery Concrete, London, (2012) (solo); *Infinials*, Tintype, London (2012) (solo); *Bloomberg New Contemporaries*, ICA, London and Liverpool Biennial, Liverpool (2012)

AYAN FARAH
b. 1978, Sharjah, UAE
2012 MA Painting,
 Royal College of Art, London
2006 Postgraduate Degree, Fine Art,
 Central Saint Martins, London
2003 BA (Hons) Fashion Design,
 Middlesex University, London
Selected exhibitions: *In The Eye of the Beholder*, Tarble Art Center, Charleston, USA (2018); Sean Kelly Gallery, New York, USA (2018); *Textile Abstraction*, Casas Riegner, Bogotá, Colombia (2018); *Ayan Farah*, Galerie Kadel-Willborn, Düsseldorf, Germany (2016) (solo); *Maps*, Pippy Houldsworth Gallery, London (2016) (solo); *Ayan Farah, Max Lamb, Chris Succo*, Almine Rech Gallery, London (20115); *Notes on running water*, Almine Rech Gallery, Brussels (2014) (solo); *The Figure in the Carpet*, Bugada & Cargnel, Paris (2014); *Proxima*, Museo Británico Americano, Mexico City, Mexico (2014); *Le musée d'une nuit (Script for living traces)*, Foundation Hippocréne, Paris, France (2014); *Ayan Farah*, Vigo Gallery, London (2012) (solo)

FRENCH & MOTTERSHEAD:
REBECCA FRENCH
b. 1973, London, UK
1998 BA (Hons) Fine Art, University
 of Wales Institute, Cardiff

ANDREW MOTTERSHEAD
b. 1968, Manchester, UK
1995 MA Site-Specific Sculpture,
 Wimbledon School of Art,
 London
1991 BA (Hons) Fine Art, Sheffield
 City Polytechnic, Sheffield
Selected joint exhibitions and events: *Kills 99.9% of All Bacteria*, CCA Derry/Londonderry (2018); *SICK!*, The Whitworth, Manchester (2017); *In Between Time*, Arnos Court Park, Bristol (2017); *Points of Departure*, Estuary Biennial, UK (2016); Resonance 104.4FM (2015); *The Homesickness Project*, Logan

Art Gallery, Queensland, Australia (2015); *Rules and Regs*, Kanagawa Arts Centre, Yokohama, Japan, and Nightingale Theatre, Brighton (2013); *Walkways*, Tate Modern, London (2012); *Over The Threshold*, The Photographers' Gallery, London (2011); *The Shops Project*, Site Gallery, Sheffield (2010) (solo)

VIKESH GOVIND
b. 1990, Leicester, UK
2011 BSc Bioveterinary Science,
 Royal Veterinary College, London
Selected screenings: *Pure*, Adcan Awards, London (2016); *Broken Ground*, Noisey, Web (2016)

RICHARD HEALY
b. 1980, London, UK
2008 MA Fine Art,
 Royal College of Art, London
2003 BA (Hons) Interactive Art,
 Manchester Metropolitan
 University, Manchester
Selected exhibitions: *The Locker Room Show*, Plymouth Rock, Zurich (2018); *The Great Indoors*, Marian Cramer Projects, Amsterdam (2017) (solo); *Lubricants & Literature*, Tenderpixel, London (2016) (solo); *Zodiac Beach*, LRRH, Berlin (2016) (solo); *Outside the Red House*, Marian Cramer Projects, Amsterdam, The Netherlands (2015) (solo); *The Pines*, White Cubicle, London (2014) (solo); *On the Devolution of Culture*, Rob Tufnell Gallery, London (2014); *Last Seen Entering the Biltmore*, South London Gallery, London (2014); *Prone Positions*, Rowing, London (part of Repeat Reverse) (2013) (solo); *Vetiver*, Marian Cramer Projects, Amsterdam, The Netherlands (2012) (solo); *But Mr Architect!*, Furnished Space, London (2012) (solo); *Strategies for Building*, Outpost, Norwich (2011) (solo); *Bloomberg New Contemporaries*, Cornerhouse, Manchester and A-Foundation, London (2009)

DES LAWRENCE
b. 1970, Wiltshire, UK
1996 MA Fine Art,
 Goldsmiths College, London
1992 BA (Hons) Fine Art Painting,
 Glasgow School of Art, Glasgow
Selected exhibitions: *Malevolent Eldritch Shrieking*, Attercliffe™, Sheffield (2018); *Really?*, Wilding Cran Gallery Los Angeles (2017); *Drawing Biennial 2017*, Drawing Room,

London, (2017); *Drawing Biennial 2015*, Drawing Room, London, (2015); *To Hope, to Tremble, to Live: Work from the David Roberts Collection*, Hepworth Wakefield, Yorkshire (2013); *Until it Makes Sense: Drawing as a Time Based Medium*, Seventeen Gallery, London and Galerie Thaddaeus Ropac, Paris, France (2006)

TOM LOCK
b. 1981, Norwich, UK
2010 MA Cinema and Visual Arts/
 Digital Creation, Le Fresnoy
 Studio National des Arts
 Contemporains, France,
2007 BA (Hons) Fine Art,
 Central Saint Martins, London
Selected exhibitions and screenings: *La respiration des yeux dans le cadre*, De Bond, Bruges, Belgium (2018); *Maximum Overdrive*, Focal Point Gallery, Southend (2017); *Selected V: Programme Selected by Jarman Award Nominees*, CCA, Glasgow; Circa Projects, Newcastle; Fabrica, Brighton; Fact, Liverpool; Nottingham Contemporary, Nottingham; Whitechapel Gallery, London (2015) (screening); *Multiplexing*, Peckhamplex, London (2014); *Late at Tate: Performing Architecture*, Tate Britain, London (2014) (screening); *Responsive Eyes*, Jacob's Island, London (2012); *Scratch the Surplus*, Deptford X, London (2012); *Breaking Points*, Past Vyner Street, London (2011) (solo); *All That Remains*, Auto Italia South-East, London (2007)

CÉLINE MANZ
b. 1981, Zürich, Switzerland
2019 MA Contemporary Art Practice,
 Royal College of Art, London
2013 BA (Hons) Fine Art, Gerrit
 Rietveld Academie, Amsterdam
Selected exhibitions and events: *Prix Photoforum 2017*, Photoforum Pasquart, Biel, Switzerland (2017); *Rythme sans fin, N° 1 – 1832*, De Appel Locus Solus, Amsterdam, The Netherlands (2016) (solo); *Museum Night*, Van Gogh Museum, Amsterdam, The Netherlands (2016) (event); *TRAINS*, De Kring, Amsterdam, The Netherlands (2014) (with Jacqueline de Jong), *Hungry for Love*, WoW, Amsterdam, The Netherlands (2014) (solo); *1 st*, Island, Hamburg, Germany (2014) (solo); *Prix Photoforum 2013*, Photoforum Pasquart, Biel, Switzerland (2013)

URIEL ORLOW
b. 1973, Zürich, Switzerland
2002 PhD Fine Art,
 University of the Arts, London
1998 MPhil Fine Art,
 The Slade School of Art,
 UCL, London
1997 Diplôme d'Etudes Supérieures,
 Aesthetics, Philosophy and
 Literature, University of Geneva
1996 BA (Hons) Critical Fine Art
 Practice, Central Saint Martins,
 London
1993 Foundation Art and Design,
 Schule für Gestaltung, Zürich/
 Wimbledon School of Art, London
Selected exhibitions, screenings
and events: *Theatrum Botanicum*,
Kunsthalle St Gallen (2018) (solo);
What Plants Were Called, PAV, Turin,
Italy (2017) (solo); *In the Peaceful
Dome*, Bluecoat, Liverpool (2017);
*Mafavuke's Trial and Other Plant
Stories*, The Showroom, London (2016)
(solo); *Uriel Orlow: Made/Unmade*,
Castello di Rivoli, Turin (2015)
(solo); *Unmade Film*, John Hansard
Gallery, Southampton (2015) (solo);
Spectrography, Depo, Istanbul, Turkey
(2015) (with Anna Barseghian and
Stefan Kristensen); *Music for Museums*,
Whitechapel Gallery, London (2015);
Inside, Palais de Tokyo, Paris, France
(2014); *Back to Back*, Spike Island,
Bristol (2013) (solo); *The Galapagos
Principle/New Waves*, Palais de Tokyo,
Paris, France (2013); *Unmade Film:
The Proposal (P)*, Whitechapel Gallery,
London (2013) (screening); *Chewing
the Scenery*, Swiss Pavilion, 54th
Venice Biennale, Venice, Italy (2011);
The Revenge of the Archive, Centre for
Contemporary Photography, Geneva,
Switzerland (2010); *Uriel Orlow: 1942
(Poznan)*, Jewish Museum, New York,
USA (2009) (solo); *Around the World
in Eighty Days*, ICA, London (2006)

RACHEL PIMM
b. 1984, Harare, Zimbabwe
2013 MA Fine Art,
 Goldsmiths College, London
2006 BA (Hons) Fine Art,
 Central Saint Martins, London
Selected exhibitions and events:
Experiments in Art + Science,
Cambridge University Gurdon Institute
and Kettles Yard, Cambridge (2018);
Rachel Pimm: Resistant Materials,
Hales Gallery, London (2017) (solo);
Landscapes of Utopia, Somerset

House, London (2017); *Rachel Pimm,
Jerwood Space*, London (2016) (solo);
SoundThought, CCA, Glasgow (2016);
*Rachel Pimm — worming out of shit —
21st Century*, Chisenhale Gallery,
London (2015) (solo); *An Evening
on The Great Pacific Garbage Patch*,
Serpentine Gallery Day, Goethe
Institut, London (2015) (event); *Natural
Selection*, Zabludowicz Collection,
London (2014) (solo); *Marmalade
Me*, South London Gallery, London
(2014); *Recent Work By Artists*, Auto
Italia, London (2013); Auto Italia
Live Episode 3: C2C P2P, Auto Italia,
London (2011); *Lucky PDF TV:
Episodes 2 and 5*, Auto Italia,
London (2010)

RENEE SO
b. 1974, Hong Kong
1997 BA (Hons) Fine Art, Royal Mel-
 bourne Institute of Technology,
 Australia
Selected exhibitions and events:
In Search of Miss Ruthless, ParaSite,
Hong Kong (2017); *Vessel Man*,
Roslyn Oxley Gallery, Sydney, Australia
(2016) (solo); *Renee So*, Kate MacGarry,
London (2016) (solo); *Selected by
Michael Marriott and Jesse Wine*,
Limoncello, London (2014); *Renee So*,
Kate MacGarry, London (2012) (solo);
Renee So, Marc Jancou Contemporary,
Geneva, Switzerland (2012) (solo);
Barbuto, Hopkinson Cundy, Auckland,
New Zealand (2011) (solo); *Renee So*,
Uplands Gallery Melbourne, Australia
(2010) (solo); *Renee So*, Kate MacGarry,
London, UK (2009) (solo); *Opera Rock*,
CAPC, Musée d'art Contemporain,
Bordeaux, France (2009); *Renee So*,
Uplands Gallery Melbourne, Australia
(2008) (solo)

ALEXIS TEPLIN
b. 1976, California, USA
2001 MA Fine Art, Art Center College
 of Design, Pasadena
1998 BA (Hons), University of
 California, Los Angeles
1998 Universita di Belle Arti,
 Bologna, Italy
Selected exhibitions and performances:
*The future is already here, it's just
not evenly distributed*, 20th Biennale
of Sydney, Sydney, Australia (2016);
Drag, Push, HOOT, Mary Mary,
Glasgow (2015) (solo); *La Grotta
Rosa*, CAR drde, Bologna, Italy (2014)
(solo); *San Marino Calling*, Museo

d'Arte Moderna e Contemporanea,
San Marino, Italy (2014); *Sacre 101
— An exhibition based on the Rite of
Spring*, Migros Museum, Zurich (2014);
sss T!!, Hayward Gallery Project Space,
London (2013) (solo); *He, Ho, HA,
hmmm...*, Mary Mary, Glasgow (2013)
(solo); *Outrageous Fortune*, Hayward
Touring / Focal Turning Point,
Southend (2011); *5cm higher*, Mary
Mary, Glasgow (2010) (solo); *The
Party*, Tramway, Glasgow (2010) (solo);
Byronic, Nottingham Contemporary,
Nottingham (2008)

ELISABETH TOMLINSON
b. 1991, New York, USA
2018 MA Education, Gender and
 International Development,
 University College London
2017 Advanced Research Certificate,
 Sculpture Department, China
 Central Academy of Fine Art,
 Beijing, China
2013 B.S. Visual Art Education,
 Roberts Wesleyan College,
 New York
Recent exhibitions include;
Experimental Materials, The Sculpture
Studio, Beijing, China (2017); *The River*,
Sixth Ring Road Museum, Beijing,
China (2016); *Force and Will*, Gongzuò
Exhibition Space, Bejing, China (2016);
*Fragments: This Obscure Object of
Desire*, Croisements Festival in collab-
oration with The Institute for Provocation
and La Cire Bleue, Beijing, China (2015);
Untitled Works, Assumption Gallery,
Cincinnati, Ohio, USA (2014)

JONATHAN TRAYTE
b. 1980, Huddersfield, UK
2010 Postgraduate Diploma,
 Royal Academy Schools, London
2004 BA (Hons) Fine Art, Kent
 Institute of Art and Design,
 Canterbury
Selected exhibitions and events:
Fruiting Habits, Friedman Benda,
New York (2018) (solo); *Dream Works*,
Kate MacGarry, London (2018);
Schussboomer, Castor Projects (2017)
(solo); *Tropicana*, Christies, London
(2017); *Milk*, Fashion Arts Foundation
Commission, Christies, London (2016);
Poly-culture, The Tetley, Leeds (2016)
(solo); *The Shopper's Guide*, Converse
X Dazed, Royal Academy of Arts,
London (2015); *Under a Pine Tree*,
Simon Oldfield Gallery, London (2011)
(solo); *Bloomberg New Contemporaries*,

Site Gallery, Sheffield and ICA, London (2011); Nude, Identity Gallery, Hong Kong (2011) (solo); Bloomberg New Contemporaries, Cornerhouse, Manchester and Rochelle School, London (2009)

TOM VARLEY
b. 1985, Keighley, UK
2017 MFA Fine Art,
 Goldsmiths College, London
2016 The Syllabus, Wysing Arts
 Centre and Partners
2008 BA (Hons) Fine Art,
 Glasgow School of Art, Glasgow
Selected exhibitions and screenings:
Here Was Elsewhere: >>FFWD,
Cooper Gallery, Dundee (2018); *Current:
Contemporary Art from Scotland*,
Shanghai Minsheng Art Museum
(2017); *We Speak Silent*, PS2
Belfast (2017); *Beatrix Kiddo,
Global Committee*, New York (2015);
Glossolalia, Tramway, Glasgow (2014)
(solo); *Tenderflix*, ICA, London (2014)
(screening); *Violence. Silence.*,
Collective Gallery, Edinburgh (2013)
(solo); *Semantic Markup Language*,
Glasgow Project Room, Glasgow (2013)
(solo); *Valise*, Volksbuehne Pavillion,
Berlin (2013)

ANDREA LUKA ZIMMERMAN
b. 1969, Munich, Germany
2007 PhD Central Saint
 Martins, London
1997 BA (Hons), Central Saint
 Martins, London
Selected exhibitions, screenings
and events: *Erase and Forget*, Rio
Cinema, London, ICA, London,
Tyneside Cinema, Newcastle and
further venues (2017—18) (screening);
Merzschmerz, Whitechapel Gallery
(2018) (screening); *Civil Rites*,
Tyneside Cinema Gallery, Newcastle
(2017) (solo); *Letter From Istanbul*,
PIArtworks, London, (2017); *Common
Ground*, Spike Island, Bristol (2017)
(solo); *Real Estates*, LUX, PEER Gallery
and Central Saint Martins Restless
Futures, London (2015); *Estate, a
Reverie*, Rio Cinema, London, Toynbee
Hall, London, Tate Modern, London, and further venues (2015—17)
(screening); *Taskafa, Stories of the
Street*, Istanbul, Turkey, International
Film Festival, Istanbul, London Turkish
Film festival, London and further
venues (2013—17); *Towards Estate*,
Whitechapel Gallery, (2012) (screen-ing and performance) *Flat Screens*,
Studio 75, Haggerston Estate, London
(2011—12); *I Am Here*, public art work,
Haggerston Estate, London (2009) (with
Lasse Johansson and Tristan Fennell)
Sadler, Daniella Shreir and the artist.

IMAGE CREDITS

By page number. All images courtesy
of the artists.

20, 22—23 Courtesy of Anise Gallery

24 Collection of Bianca Roden and
Karen Smith. Image courtesy of
Blain|Southern. Photo: Peter Mallet

25 Collection of Jane Cowan and
Roland Cowan. Image courtesy of
Blain|Southern. Photo: Peter Mallet

26 Courtesy of Blain|Southern
Photo: Peter Mallet

28—29 Photo: Anna Arca

31 Collection of Delia Phillips
Photo: Anna Arca

34 Photo: Jess Littlewood

35 Photo: Toni Marshall

36—37, 39 Photo: Louca Studios

44—46 Courtesy of Kadel Willborn,
Düsseldorf and Pippy Houldsworth
Gallery, London

50 Courtesy of The Whitworth,
Manchester. Photo: Jonathan Keenan

51 Photo: CCA Derry / Londonderry

56—57 Courtesy of Tenderpixel,
London. Photo: Original&theCopy

58—59 Courtesy of Tenderpixel,
London

60, 61—62 Photo: Todd White
Art Photography

64, 66—67 Courtesy of Focal
Point Gallery Soundtrack by
Manuela Barczewski and Rudi
Schmidt. Commissioned by
Focal Point Gallery, 2017

68 Installation views: Kunsthalle Basel.
Courtesy of Kunstkredit Basel-Stadt
Photo: Nici Jost

80 Courtesy of Kate MacGarry

82 Courtesy of Kate MacGarry
Photo: Angus Mill

83 Courtesy of Kate MacGarry.
Photo: Robert Glowacki

84, 86—87 Courtesy of Mary Mary,
Glasgow

94 Photo: Andy Keate

102 Collection of Pat Garrett

103 Courtesy Gatwick Detainees
Welfare Group and Refugee Tales
Photo: Chris Orange

ACKNOWLEDGEMENTS

WHITECHAPEL GALLERY SUPPORTERS

THIS EXHIBITION HAS BEEN GENEROUSLY SUPPORTED BY
Ravi Chidambaram and Yana Frey, Evgeny Tugolukov and Natalya Pavchinskaya

ARTWORK INSURANCE PARTNER

HISCOX

SPECIAL THANKS TO
Janine Catalano, Dor Duncan, Paul Hedge, Pippy Houldsworth, Iris Kadel, Jenny Lea, Daryl de Prez, Moritz Willborn

WHITECHAPEL GALLERY TRUSTEES
Chairman: Alex Sainsbury

Swantje Conrad, Maryam Eisler, Ann Gallagher, Anupam Ganguli, Clrr Daniel Hassell, Nicola Kerr, Farshid Moussavi, Catherine Petitgas, Alice Rawsthorn.

WHITECHAPEL GALLERY STAFF
Anne Akello-Otema, Verissa Akoto, Chris Aldgate, Daniel Allison, Molly Baro, Safwan Bazara, Iwona Blazwick, Emily Butler, Gabriela Cala-Lesina, Janine Catalano, Erin Cork, Inês Costa, Sarah Crocker, Amina Darwish, Helen Davison, Clio Delcour-Min, Luke Drozd, Dor Duncan, Daniel Eaglesham, Sue Evans, Cameron Foote, Trinidad Fombella, Tim Gosden, Doireann Hanley, Sam Hailey-Watts, Lucy Hawes, Bridie Hindle, Oscar Holloway, Alexandra House, Rosie Kennedy, Jenny Lea, Taylor Learmouth, Ryszard Lewandowski, Marthe Lisson, Sandra Louison, Kirsty Lowry, Valentina Mennella, Hannah Milligan, Glen Moxon, Rummana Naqvi, Renee Odjidja, Divya Osbon, Alana Pagnutti, Justine Pearsall, Katherine Proudlove, Habda Rashid, Elsa Richmond-Seaton, Jessica Roper, Jane Scarth, Vicky Scott, Antonia Seroff, Priya Shemar, Carolina Silva, Laura Smith, Irene Sola, Chris Spear, Vicky Steer, Tony Stevenson, Candy Stobbs, James Sutton, Polly Thorburn, Mercedes Vicente, Sofia Victorino, Francesca Vinter, Sam Williams, Monica Yam, Lydia Yee, Nayia Yiakoumaki, Andrea Ziemer-Masefield.

The Whitechapel Gallery would like to thank its supporters, whose generosity enables the Gallery to realise its pioneering programmes.

EXHIBITIONS PROGRAMME
Air de Paris, Paris
Institut für Auslandsbeziehungen e. V. Stuttgart
The Barjeel Art Foundation
Cockayne Grants for the Arts
Maryam and Edward Eisler
FACT
The Embassy of the Federal Republic of Germany
Henry Moore Foundation
Konrad Fischer Galerie
David Knaus
kurimanzutto
The Robert Lehman Foundation
Galleria Lia Rumma, Milan/Naples
London Community Foundation
Galeria Luisa Strina
Georg Kargl Fine Arts
Mai 36 Galerie Zurich
Collezione Maramotti
Marian Goodman Gallery
Max Mara
kamel mennour
NEON
New Hall Art Collection, Murray Edwards College, University of Cambridge
Paul Mellon Centre for Studies in British Art
Catherine Petitgas
Ministry of Culture and National Heritage of the Republic of Poland and Culture.pl
Polish Cultural Institute in London
Galerie Rüdiger Schöttle
Sprüth Magers
Maria and Malek Sukkar
Tanya Bonakdar Gallery
V-A-C Foundation
The Whitechapel Gallery Commissioning Council
David Zwirner
and those who wish to remain anonymous

PUBLIC EVENTS PROGRAMME
Goethe-Institut in London
Stanley Picker Trust
Pictet & Cie
Office for Contemporary Art Norway (OCA)
The Royal Norwegian Embassy in London

EDUCATION PROGRAMME
Artworkers Retirement Society
The Barjeel Art Foundation
The Bawden Fund
Capital Group
Paul Hedge and Paul Maslin, Hales Gallery
Howard Hodgkin Estate
iaspis
NADFAS
Marion Smith QC and Alex Macgregor Mason
Swarovski Foundation
The Embassy of Sweden in London
The London Borough of Tower Hamlets
Kevin Wulwik

CAPITAL RENEWAL PROGRAMME
The Wolfson Foundation

FRAMING PARTNER
Frame London

WHITECHAPEL GALLERY CORPORATE PATRONS
Bloomberg
Frasers Property UK
Gazelli Art House
Phillips
South Street Asset Management

WHITECHAPEL GALLERY CORPORATE SUPPORTERS
Alhambra
Crossrail
Frame London
Hiscox
Swarovski
Wild Bunch & Co

FUTURE FUND FOUNDING PARTNERS
Mahera and Mohammad Abu Ghazaleh
Sirine and Ahmad Abu Ghazaleh
Swantje Conrad
Mr Dimitris Daskalopoulos
NEON
Maryam and Edward Eisler
V-A-C Foundation
Sir Siegmund Warburg's Voluntary Settlement
Arts Council England Catalyst Endowment Fund

FUTURE FUND SUPPORTERS
John Smith and Vicky Hughes
Dominic Palfreyman

WHITECHAPEL GALLERY
COMMISSIONING COUNCIL
Erin Bell
Leili Huth
Irene Panagopoulos
Catherine Petitgas
Mariela Pissioti
and those who wish to remain
anonymous

WHITECHAPEL GALLERY
DIRECTOR'S CIRCLE
Selina Beaudry
Erin Bell and Michael Cohen
D. Daskalopoulos Collection Greece
Michael and Nicolai Frahm
Peter and Maria Kellner
Luigi Maramotti
Yana and Stephen Peel
Catherine Petitgas
and those who wish to remain
anonymous

WHITECHAPEL GALLERY
CURATOR'S CIRCLE
Sarah Griffin
Katharina and Jens Hofmann
Chris Kneale
Adrian and Jennifer O'Carroll
Dasha Shenkman
Audrey Wallrock
and those who wish to remain
anonymous

WHITECHAPEL GALLERY
PATRONS
Malgosia Alterman
Beverley Buckingham
Angela Choon
Matt Carey-Williams
and Donnie Roark
Sadie Coles HQ
Beth and Michele Colocci
Swantje Conrad
Alastair Cookson
Elizabeth Corley
Aud and Paolo Cuniberti
Dunnett Craven Ltd
Darryl de Prez
Belinda de Gaudemar
Sarah Elson
Nicoletta Fiorucci
Theresa Froehlich
Lisa and Brian Garrison
Alan and Joanna Gemes
Richard and Judith Greer
Jill Hackel

Louise Hallett
Frank Krikhaar
Xi Liu and Yi Luo
Maria Meijer
Victoria Miro Gallery
Jon and Amanda Moore
Heike Moras
Farshid Moussavi
Bozena and William Nelhams
Angela Nikolakopoulou
Maureen Paley
Jasmin Pelham
Alice Rawsthorn
Frances Reynolds
Alex Sainsbury and Elinor Jansz
Cherrill and Ian Scheer
Matthew Slotover and Emily King
Karen and Mark Smith
Louise Spence
Bina and Philippe von Stauffenberg
Mr and Mrs Christoph Trestler
Yusi Xiong
Lian Zhang
Sharon Zhu
and those who wish to remain
anonymous

WHITECHAPEL GALLERY
FIRST FUTURES
Cedric Bardawil
Irene Barontini
Crane Kalman Gallery
Olga Donskova
Siena Erbe
Jude Hull
Zoe Karafylakis Sperling
Daria Khan
Ezra Konvitz
Marie Krauss
Dominika Kulczyk
Petra Kwan
Lucy Loveday
Celia Lloyd Davidson
Di Luo
Supriya Menon
Victoria Mikhelson
Reine Okuliar
Indi Oliver
Olga Peftieva
Maria-Cruz Rashidan
Eugenio Re Rebaudengo
Henrietta Shields
Kanwar Amarjit Singh
of Kapurthala, India
Tammy Smulders
Julianna Sseruwagi-Nisbett
Joe Start
Aisha Stoby
Louisa Strahl
Nayrouz Tatanaki
Lawrence van Hagen

Giacomo Vigliar
Elisabeth von Schwarzkopf
and those who wish to remain
anonymous

We remain grateful for the
ongoing support of Whitechapel
Gallery Members.

The Whitechapel Gallery is proud
to be a National Portfolio Organisation
of Arts Council England.

Supported using public funding by
**ARTS COUNCIL
ENGLAND**

Published on the occasion
of the exhibition:

THE LONDON
OPEN 2018
Whitechapel Gallery, London
8 June–26 August 2018

EXHIBITION
Mahera and Mohammad
Abu Ghazaleh Curator: Emily Butler

Assistant Curator: Cameron Foote

Exhibitions Assistant: Inês Costa

Head of Exhibition Design and
Production: Christopher Aldgate

Gallery Manager: Ryszard Lewandowski

Installation Coordinator: Chris Spear

Curator: Public Programmes:
Jane Scarth

Exhibition Placement:
Elsa Richmond-Seaton

PUBLICATION
Editors: Emily Butler
and Cameron Foote

Copy Editor: Melissa Larner

Publication Manager: Francesca Vinter

Design: Rafael Camisassa
and Christopher Lacy

Printed by KOPA, Lithuania

ISBN 978-0-85488-264-9

First published 2018
by Whitechapel Gallery, London
© 2018 Whitechapel Gallery
and the authors
All artworks and photographs
unless otherwise noted
© the artists

A catalogue record for this book is
available from the British Library

Whitechapel Gallery
77–82 Whitechapel High Street
London E1 7QX
whitechapelgallery.org

Distributed by
Central Books
50 Freshwater Road
Chadwell Heath
London RM 8 1RX
Tel: +44 (0) 20 8525 8800
orders@centralbooks.com